THE ULTIMATE
FIELD GUIDE TO
DIGITAL
VIDEO

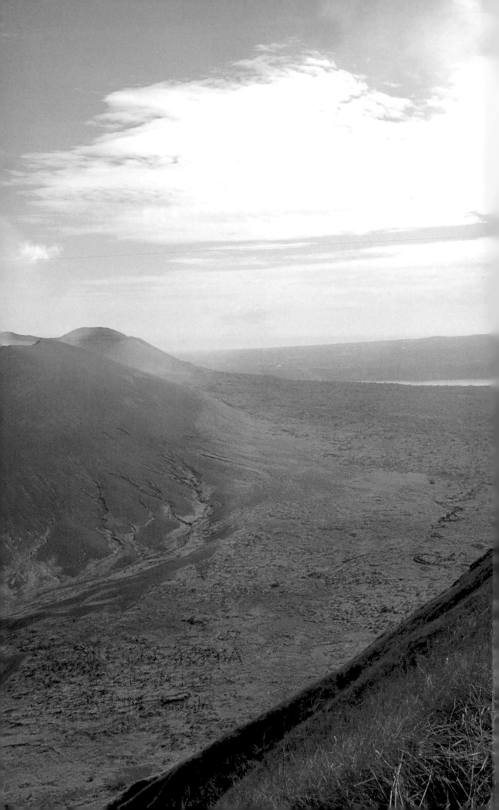

THE ULTIMATE FIELD GUIDE TO
DIGITAL VIDEO

RICHARD OLSENIUS

NATIONAL GEOGRAPHIC
WASHINGTON, D.C.

CONTENTS

Opposite: Old-fashioned color bars sometimes appeared at the beginning of old television shows. Previous page: Richard Olsenius prepares to film a scene on a mountaintop in Nicaragua.

Foreword

by John Bredar, Filmmaker and Executive Producer, National Geographic Specials

One irony about being a television producer/director is that I don't often operate the video camera. My wife even chides me for possessing an ancient Hi-8 video camcorder at home instead of a more modern version. But filmmaking is not a one-person job: it is a collaborative effort. During the production of the twenty-five films I've made for National Geographic, I have always worked closely with outstanding cameramen to get the killer shots and remarkable moments that often define the films.

Except once. It was during the production of *Inside the Vatican*, a two-hour documentary special. Prior to filming on location, I spent a year trying to gain access to unique places and moments. It was a frustrating process. I got a sense of just how tough it would be at one of my first meetings with a high Vatican official. His name was Cardinal Noe (pronounced NO-WAY). The key scene I wanted to film was a visit by a person or a group–more commonly known as an audience–with Pope John Paul II. At the time, Vatican officials were skittish about cameras near the Pope whose health was deteriorating. I wasn't too hopeful about getting this sequence.

Then one day—after we had been shooting for three months—my main contact at the Vatican rushed up to me in St. Peter's Square. "Well, you'll never believe this, but you have permission to film with the Holy Father! You have to go right now!" After a year of preparations, twenty requests, and three months of filming, we were finally going to have the key scene we always wanted.

Then the bombshell: "There's only one restriction. You have to shoot it."

Suddenly, one of the key moments of the movie was going to be in my oh-so-unprofessional hands. I knew how I wanted it to look, which shots to get, and how it would all fit into the story. But actually getting the shots? That's why I worked with a cameraman. In the end, the scene with the Pope worked out well. I got the key shots (mostly). The camera was steady (pretty much). We were able to build a sequence (barely).

But the lessons I learned that day are the lessons you will learn here. First, study your camera. It doesn't really matter which model you are using but it really matters that you know how to use it well. Ask yourself why you want to shoot something. Is it a story you want to tell or a record of an event like you see on the C-Span network?

If you choose the story approach, you will be working the way I work. In the process of making a film, I actually make the film three times. First, I research the topic and write a detailed treatment to produce a shooting script. This is my outline and I have now made the film in my head. Next, I go out into the field with my team and my outline and I make the film a second time. This part isn't usually easy, especially when animals are involved. However, you film as much as you can. I make the film the third and final time in the edit room. Here you find out where you made all your mistakes in the field and you learn the most about the process. This is the truth stage because you can't make a movie with sequences you did not get. In rare instances, the final version actually looks and feels like that first version you made in your head.

One final thought before you roll your first tape. Nothing beats listening carefully as the key element of a good film. Some of the greatest moments in documentary films happen because of what's being said by the people in front of the camera. The goal is for you and the camera to become part of the conversations, yet separate and unobtrusive so real life can happen on film/video.

My colleagues at National Geographic Television have received more than 900 industry awards—including 124 Emmy awards—and when Richard Olsenius proposed this book as the next edition for the popular National Geographic Ultimate Field Guide to Photography series, we couldn't have been more pleased. A filmmaker and photographer himself, Richard knows how to dissect the process of filming and he is able to describe it in plain old-fashioned language. We hope you will agree.

Happy filming and just remember—imagine your story, unplug your ears, then push the red button.

Chapter 1
Introduction to Digital Video

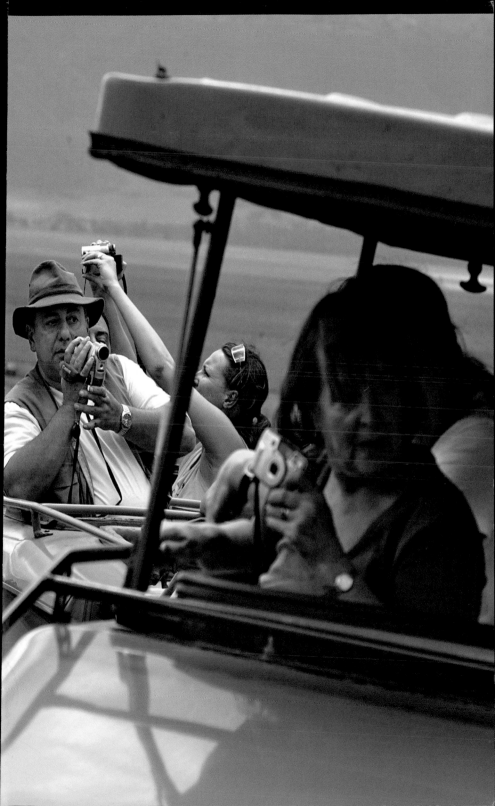

1 | *Introduction to Digital Video*

n 1964 Marshal McLuhan, the pop guru of the counterculture generation during the 1960s, predicted that television, cameras, and computers would evolve in such a way that our vision of the world could and would be forever altered. In other words, these technological tools would become as important, if not more, than the stories or ideas we were relating. Hence the phrase was born—"the medium is the message."

Over the past several decades, the moving image has irrefutably become one of our main channels of communication, and now with broadband Internet, another doorway has opened with exciting and innovative ways to tell and share the human story. Of parallel importance, the last decade has seen expensive digital tools once used by a handful of video professionals dramatically reduced in size and cost. Today, almost everyone can make films at a fraction of what it once cost.

On a recent assignment to Nicaragua and Guatemala, I was able to pack a small, under-the-seat Pelican case that included a High-Definition video camera, twenty hours of tape, three batteries, a fluid-head tripod, and a battery charger. I also squeezed in an 8-megapixel still camera with the ability to shoot short bursts of video. Most important, it was a camera not much bigger than a credit card that, in a pinch, could shoot still images for my video production.

THE FIRST CHALLENGES

In a world where digital video is omnipresent, the challenge lies not in the money one needs to spend but in choosing the right camera for the right project. I don't mean to be insensitive about the money factor when choosing a camcorder, since many of us don't have extra cash to buy every new video toy that hits the market. It is good, however, to keep in mind that for every new camcorder bought, a used camcorder becomes available. Websites like eBay can be a treasure trove of good, usable, and reasonably priced gear. If you want to shoot video, now is the right time to start.

The next challenge is learning how to use your camcorder so you can take advantage of all the new technological advances to create your masterpiece. The goal of this field guide is not to make shooting video a complicated technical exercise. In simple, direct steps, I'll show

iPods and MP3 players are changing the way we view movies and look at images.

you how to (1) buy the right gear for your needs, (2) shoot your video, (3) edit your video in a logical way, and (4) share your video with friends or people around the world.

The reality is that the majority of people who go out and buy a video camera have just one thing in mind, and that's usually capturing their family growing up and then sharing these images with close friends and far-flung family members. The films can be as simple as turning on the camcorder and recording an event. Or one can make it more interesting by taking the time to learn the more simplified editing softwares that are bundled with many home computers today. A little effort today can save you a lot of aggravation and boring hours of viewing later.

THE NEXT CHALLENGES

For those who are ready to make an effort to develop a simple process, the reward will be a rich and interesting video archive. Over the years I have acquired sophisticated computer screens, the capability to make my own music with a keyboard and software, and many, many hard drives filled with my efforts. For me, sharing videos around the world is fresh and exciting because it has been made easier by the newer small cameras, a choice of inexpensive editing tools, and blazing broadband Internet speeds.

Not too long ago—when I made a film about the Great Lakes—I had to rent a $300/hour editing suite to piece together a video shot on 3/4-inch tape. The camera and deck weighed in at maybe 45 pounds, and I needed a storeroom for all the cassettes shot on the project. A number of successful showings on PBS were the result, yet distributing this video on 3/4-inch tape and VHS was economically impossible. I had to remain happy with the time slots I had been given. For other small independent producers it was also tough to get their videos shown outside of

Cameraphones capture video that can be shared with friends almost instantaneously by sending it to them over wireless networks.

film festivals. Needless to say, most of us produced a film or two at the most.

The advent of digital technology gave us the ability to master and duplicate our films and videos without losing quality. For a fraction of the cost to make duplicate tapes, we now have the chance to distribute our videos to more sources. The high caliber of cameras available have also given us the capability to make quality videos.

I believe we're entering an important era in which the fascination with equipment and gadgetry will be balanced with

Digital video is compatible with both small and large screens.

One of the best methods of learning to see and tell stories when you are just beginning is to focus on the shooting techniques and not on the best equipment to buy. That can come later when you learn the principles.

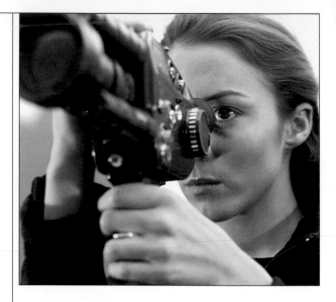

innovative story-making. For the first time in history, major film companies will have to share the marketplace with many more new independent producers.

TWO METHODS OF LEARNING

There are two routes one can take when approaching the idea of shooting digital video. The first method is to sit down with a book like the one you're reading and get a basic understanding of how to choose a camera and shoot and edit video. There's nothing wrong with this if you eventually put down the reading material and make some video. The second approach is more impulsive—buy a camera, turn it on, and figure out the controls. When you get stuck, then you can read the manuals. I think many people learn faster this way. But is it the best way? The goal should be to develop a basic understanding of the camera along with rudimentary shooting and editing techniques so you can move on to the real reason you bought this gear: to record the people and places that interest you and share them with others.

A LITTLE MORE HISTORY

I don't think it hurts to know a little bit about what preceded that tiny camcorder you're holding in your hand. Imagine the men and women who set out to map the American West during the 1800s. In order to under-

stand their story, is it absolutely necessary to stand in the wagon-wheel ruts of the Oregon Trail? No, but there's a certain amount of sensitivity and understanding that can be created by taking a moment to think about the impact history has on a particular subject. Okay, at least indulge those of us who had to learn this craft with bulkier equipment and shorter tapes!

It was 1956 when Ampex Corporation successfully designed a machine that captured on magnetic tape the live video images shot with bulky studio television cameras. Ampex sold one of the first of its videotape recorders (VTR) for $50,000 to the Central Broadcasting Sytem—better known as CBS Television—which aired the program *Douglas Edwards and the News* on November 30, 1956. It was the first network television show broadcast on videotape. Although the machines were big, complex, and prone to breaking, this was an incredible step. Instead of live television, producers could record an event to "tape" for replay at a later time. The large reels of magnetic tape were made by the 3M Company and sold for just over $300 a reel.

For nearly twenty years this complex technology was the sole domain of the studios while consumers were still using their 16mm and eventually 8mm film cameras. Kodak couldn't churn out the film fast enough. It wasn't until 1975 that this videotaping technology finally reached the consumer market when Sony introduced its groundbreaking Betamax home recording system. The Beta format was an immediate success with a growing number of video enthusiasts who now could record and watch their shows whenever they wished. JVC marketed the more compact Video Home System (VHS) the following year in an effort

During the short time that film and video cameras have been around, the size, weight, and quality of the cameras has changed dramatically. At back left is an Ikegami video camera and back right is a 16mm film camera with a 400 foot film magazine attached. In the front are more modern video cameras.

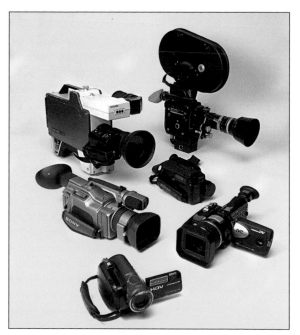

to compete with the bulkier Betamax system. In the end, the VHS system triumphed when Sony began making VHS players, in 1988, and phased out its Betamax units.

Regardless of the system chosen, the manner in which viewers watched television changed forever. People no longer felt beholden to network television programmers to tell them when they could watch a particular show. They learned to tape episodes to view them later. This desire has now extended to films with movie-on-demand capabilities and home theaters.

The same transition has happened among filmmakers. Sony created a bulky but portable videotape camera in 1983. Some of you may remember the hysterical footage of someone balancing on one shoulder a Betamax camera the size of a small suitcase while trying to capture moving images of the family vacation to the Grand Canyon. The engineers at Sony quickly developed a palm-sized "handycam" two years later that used a new small 8mm videotape.

While the new miniature cameras were affordable and more fun to use, the quality of the video was not as great. This shortcoming, however, didn't stop many commercial producers or consumers from shooting and experimenting with these new lightweight video cameras. Producers today still use these same cameras because of the look and feel of the video the cameras make. They help identify a look of the 1980s that some advertisers and filmmakers covet.

Digital video camcorders arrived in 1996. Sony and Canon introduced the "Mini-DV" tapes along with these cameras. The cameras and the tapes looked virtually the same as their analog predecessors, but the difference was immediately noticeable during the editing process. Editors could edit and reedit digital tapes without the fading and signal degradation during the dubbing and editing processes that analog tapes suffered. Multiple copies could also be made for a fraction of the cost for dubbing analog tapes.

So now, video-making capability is everywhere. You probably have the capability to make a two-minute film on your cameraphone or on your still digital camera. Camcorders are sold in big box stores as well as camera stores and through online businesses. The only factor that can hold you back is time and effort.

Video cameras are also used by artists as tools of expression to create video installations.

BROADBAND OPENS THE DOOR

The distribution of video has never been faster and easier than it is today. Network television companies and cable companies are rapidly changing their business models as independent producers create high-quality, innovative programming to distribute on their own. Coupled with the availability of High-Definition camcorders and big, beautiful plasma screens, a whole new viewing experience exists for all of us.

In the next chapter you will learn about the differences in cameras, formats, and functions before you set out to shoot your first video. But take some time to study the editing chapter before you start. Your friends and family will be glad you did!

Choosing the
Right Camera

2 Choosing the Right Camera

Around 1980, consumer video was in its infancy and 16mm film was the more practical option for small independent filmmakers. Shooting film was exciting, but the cost of film stock—running through the camera at 400 feet in 11 minutes—made random shooting almost financially impossible. A high-quality 16mm movie camera with good lenses was barely affordable. Now I can't help but smile every time I slip four hours of Mini-DV tape into my jacket pocket and hang a lightweight High-Definition digital video camcorder from my shoulder. Times do change!

Digital video has helped to open the door to an age of self-expression, a practice that doesn't still require a second mortgage on your home to pay for it. The evolution of today's consumer digital video offers some of the most sophisticated video cameras ever, and there's no indication this innovation is slowing. With Apple Computer's new Intel dual-core computers and Windows-based personal computers outfitted with video media elements, you have the ability to create high-quality, award-winning videos at your fingertips.

Digital video has been available to the consumer for about 10 years. What makes a video camera digital? Simply put, digital video (DV) is an imaging process that starts when light passes through the camera's lens and is focused onto a sensor in the form of a chip now located where the film use to sit. This chip, with millions of light-detecting elements, or pixels, receives the focused image on its surface and converts the light and color values into digital data, which it then transfers every 1/60 second (a variable that depends on the camera) to the video camera's internal processor. The video camera compresses this huge data stream to a manageable size that can be transferred to storage, such as a Mini-DV tape or DVD, or flash memory, or a small hard drive inside the camera. It's hard to believe that engineers have miniatur-

ized these functions into something you can hold in the palm of your hand. Even more amazing is the ability now to transfer this high-quality video and stereo-sound recording directly to your computer for editing and archiving.

Natural light is the best option for making good video footage when you are just beginning.

THINGS YOU SHOULD KNOW ABOUT SENSORS

Video cameras, or camcorders, come in all sorts of technical flavors, with the sensor—or chip—being one of the main ingredients. There are three factors to consider with regard to the sensor. First, which of the two main types, CCD or CMOS, does the camera use? Next, how big is the sensor? And third, but of no less importance, how many chips does the camcorder have and how many do you really need?

CCD or CMOS Chips

As a general rule, CCD (charge-coupled device) sensors are found on the more expensive digital video cameras. The video tends to be of a higher quality than CMOS sensors produce. CMOS (complementary metal-oxide semiconductor) chips are much cheaper to manufacture and are usually found on less expensive cameras. In the past, they have had issues with creating noise in the image, although this seems to be improving. There is now less difference between the image quality produced by the two kinds of chips in low- and mid-priced cameras. CMOS chips also tend to do poorly in low-light conditions. (Canon has had some success recently with CMOS, but CCD is still preferred by most manufacturers.) For the rest of this book—for simplicity's sake—I will be talking about CCD chips unless otherwise specified.

Is a Bigger Sensor Better?

Sensors—whether CCD or CMOS—come in different sizes. The standard sizes are 1/2 inch, 1/3 inch, or 1/4 inch. Most consumer video cameras have one chip in the 1/4-inch size or smaller. As a general rule, a larger sensor is better because it contains more pixels and the pixels themselves can be larger. Larger pixels are more sensitive to color and light differences which can also mean there is less noise—a grainy look in the video—in your footage. A smaller sensor can also boast a very high pixel count, but the pixels themselves must be of necessity smaller. As a result, there is a chance that the entire sensor is less sensitive to light and color differences overall than a larger sensor. Monetarily, the larger the sensor, the more expensive the camera will be.

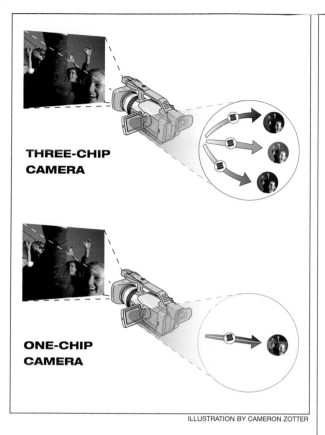

THREE-CHIP CAMERA

ONE-CHIP CAMERA

One-chip cameras must process light into red, green, and blue channels, which might deliver a color signal slightly inferior to a camera that has three chips, one dedicated to each color channel.

How Many Chips Do I Need?

More expensive "prosumer" camcorders have three CCD chips and are also slightly larger with more pixels. There's a significant reason more expensive video cameras come with three CCD chips. All video cameras, whether containing one or three chips, must convert the image into RGB (red, green, blue) channel data. In three-CCD camcorders, the fidelity of the processed color signal is greater because the incoming light is split into three channels (one each for red, green, and blue) to be processed on their respective chips with usually superior results. It's not essential to have a three-CCD camcorder, but most professionals and serious amateurs prefer the quality of the color signal.

The bottom line is camcorders with three CCD chips are better than camcorders with one CCD chip. However, if you're shooting for yourself—or you are on a very tight budget—camcorders with one chip are an

excellent value. I have been shooting with a one-chip High-Definition camcorder from Sony that fits in the palm of my hand and I am amazed at the quality of the video as compared to my three-chip High-Definition camera, which is bigger and heavier.

HOW TO BEGIN

One good way to decide on the camcorder you need is to write down your goals for you and your camera. The shelves are filled with video cameras that look the same. And the companies change their models so frequently that you'll probably feel like you bought an outdated video camera before you've even left the store.

A list will be a big help in deciding what you need to look for in a video camera. Often it will cost more in the long run to buy the cheapest brand—or someone's outdated hand-me-down—than to get the camera suited for your plans and your computer. You need a camcorder that can work with your editing software and your computer. Ignoring these facts can and will affect your finished videos.

The intense competition in the video camera industry is very good for the consumer. The features on most camcorders today are nothing short of phenomenal. So much, in fact, that what is now available at the high end of consumer video surpasses what the pros had been using a few years ago. For instance, ten years ago one of the first digital still cameras cost close to $20,000 and the image size it produced was only 3 megapixels. Today, you can buy a still camera that makes an 8-megapixel file for less than $500.

WHAT ARE YOUR VIDEO NEEDS?

- To document family events for personal use?
- To record friends and events to share in a blog or other Web format?
- Do you need to combine stills with video?
- To pursue a subject area of personal interest for sharing on the Web?
- To make money shooting video for commercial clients?
- To make video statements for distribution or sales?
- To shoot High-Definition video for a wider audience?
- To go to Hollywood as a filmmaker?

Research Features

There are many different features and capabilities available in video cameras. With your list of needs in mind, the Internet is a good place to begin to research the marketplace. Look at manufacturers' websites for the features the latest video cameras have. Read independent reviews on the websites suggested on page 26. Ask people you know who own a video camera what they like and dislike about the camera they chose.

I've made a lot of purchases at reputable online stores over the years and I am rarely disappointed. I do, however, compare camcorders I like with camcorder company websites such as Nikon, Canon, and Sony to see what they are offering as well. Be aware that what you see online are the most recent video cameras, and some of these models may not have been shipped to retail outlets yet.

A trip to your local camera store to see what's available is a good idea. Often you will find a salesperson who can give you a good comparison of brands and features in a way you can't get online. You might find a good deal there too. A word of warning: Be wary of any camera that seems too good to be true. It probably is.

It pays to take a small amount of time to look below the surface of the camera you plan on buying. Use the Web to read reviews and technical specifications. Then compare.

TIP:
Websites that you can use to research cameras
www.dv.com
www.adamwilt.com
www. camcorderinfo.com

In 1995 the Sony VX1000 was the first lightweight digital camcorder available in the marketplace.

The Difference in Digital Formats

Almost all video cameras on the market today are digital. When salespeople talk about digital video (DV), most of them are talking about video cameras that store their video data or images on Mini-DV tapes. DV—an industry standard introduced around 1995—is now supported by over sixty companies that make video cameras and accessories. The data storage unit—called a Mini-DV—is a 1/4-inch tape coated with evaporated metal and housed in a small plastic cassette that can contain an astonishing 11 gigabytes of data, or about an hour of video. The resolution of the images is about the same as that made by professional digital Betacams. The high compression of image data on the Mini-DV tape, however, cannot be similar in quality to the output from a

$40,000 professional video camera. But it's darn close!

DV was a major factor in the dramatic reduction in camera size from the old VHS cameras—and somewhat smaller Hi8 cameras—that made videographers look like a Flintstones news team. Recently, other formats have evolved and are definitely worth your consideration. Just remember that when the salesperson is extolling the values of digital video, not all formats are DV. These new formats don't deliver or store the same quality of video footage.

The Essentials of Storage

How a camcorder compresses the video frame data onto tapes, cards, or disks—the three ways of storing video data—is important to the final quality of your video. You need to decide exactly what level of quality and long-term accessibility you are looking for in a digital video camera before you buy the camera.

Mini-DV tapes hold about an hour's worth of video, or about 11 gigabytes of data. The quality of the compression is quite good.

My biggest concern, besides quality, is about long-term usability. Will the format or medium (tape, disk, or card) on which the camera's video is stored change or disappear? How terrible would it be to have a drawer full of videos that you or your grandchildren could not play because the camera and its format no longer existed? It's the same issue that exists regarding 16mm films, Betamax, VHS, Hi8, and other older formats. Who has the machines to play these outdated films and video?

As you explore video cameras and their formats, keep these questions in mind and stay away from formats that are either too new, too proprietary, or unpopular. There is nothing in this technological age that can absolutely protect you from eventually having outdated gear. However, my recommendation is to stick with the most popular format, which is DV and Mini-DV tape. It has been around in one form or another for a decade and continues to be the format of choice in the high-end prosumer market. The Mini-DV tape transport systems are relatively rugged, hold a tremendous amount of video for the cost of a tape, and also capture (as of this writing) the highest resolution video.

That said, you should also take notice of some new-comers in the format arena. These are the High-Definition camcorders that have been introduced by Canon, Sony, JVC, and others. Through the feat of

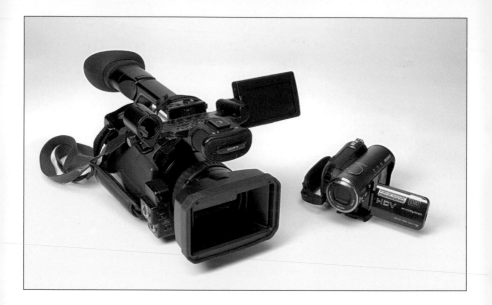

The next generation of High-Definition video cameras are available in a wide price range of hundreds to thousands of dollars. You usually get what you pay for, so be careful.

technological engineering and new video compression schemes, these cameras use the same Mini-DV tape so popular on the DV cameras. The similarity stops there. Once you see video shot with one of these HD cameras displayed on a large HD flat-panel television through a digital interface called HDMI (High-Definition media interface), you may be as impressed as I am with the new technology. Because HD is a new entry in the video format arena, there are still obstacles to overcome in the stages of editing and sharing HD video. Given its popularity, however, I'm sure they will be resolved soon.

When choosing a camcorder, examine the number of memory chips, the amount of video storage, and the special features to help you sort through the maze of models.

MINI-DV VIDEO CAMERAS

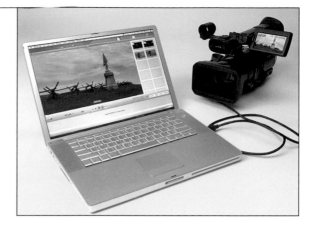

As I've pointed out, DV is the most mature of the consumer digital video formats. Professional videographers—from journalists to wedding photographers—immediately loved this video format because of its quality, size, and low cost. The format was also easy to edit on their computers. Although these video cameras have continued to shrink in size and price during the last 10 years, most still have an astonishing number of features.

One of the most important aspects of DV cameras with their Mini-DV tapes is the FireWire interface, the cable connection between the camcorder and the computer that allows for the transfer of the captured video. (FireWire is Apple's proprietary name for the IEEE 1394 interface. It is also known as i.Link or IEEE 1394 by other manufacturers and computer companies.)

This connection was a truly amazing development for those of us struggling with transferring video data into our computers using other types of old low-quality equipment and compression schemes. Today, all video-editing programs can edit in the Mini-DV compression scheme, a system that allows for many levels of sharing and storage or the duplication of your video without a generational loss of quality. Generational loss, or degradation of quality, used to happen every time you transferred, copied, or applied special effects to analog video.

Another format—DVCAM—is similar to DV but requires a larger cassette. Some DV prosumer decks will play both DV and DVCAM but, for the most part, the tapes are not interchangeable between the two formats. The quality of the image DVCAM captures is not noticeably that much better than the quality of DV. The difference is in the camera; DVCAM plays and records in cameras outfitted with higher-quality lenses and transport systems. Hence, the format is more expensive. Some photographers claim they get fewer dropouts

High-end consumer camcorders connect to your computer either through FireWire or USB port, providing an easy way to download your video for editing and archiving.

(slight errors in dropped data that result in visual artifacts or banding) with DVCAM.

When it comes to buying tape, I strongly suggest you buy the tape recommended by the camcorder manufacturer and avoid buying the cheaper generic brands.

DVD CAMCORDERS

If all you want is a fast and simple way to shoot the family reunion onto a DVD that you can pop unedited into your home DVD player, this might be the right camcorder for you. Nothing could be easier. That's the appealing side of this video format—simplicity.

There are some drawbacks, however. The first is the small video-storage capacity of the 3-inch DVD. It can hold only about 30 minutes of video (this can vary with quality settings). Many of the cameras come with a media cable that connects just to DVD players. This rules out an easy connection and download to your PC or Apple computer for computer video editing. (Most video-editing programs cannot capture video straight from the DVD.) Some of these cameras—which typically

Capturing video on a playable 3-inch DVD is the fastest method if you simply want to shoot and play. If you intend on editing your work a lot, this may not be the best option for you.

use MPEG-2 video compression—don't deliver the image quality of DV either.

If you can, you should test whether the DVD taken out of the video camera you like will play on your home DVD player.

MEMORY CARDS AND MICRODRIVES

A new type of video camera stores your videos on memory cards or microdrives (super-small hard drives). As the price for flash memory drops, these palm-sized recorders have become very reasonable.

If you love the tiny technologies, just be aware of the storage capacity and the video compression (codecs) your camera uses.

The idea of a tapeless camera is an interesting one. The ability to shoot and transfer video to a computer by popping a card into the reader makes it a simple matter to share video on the Web or in an e-mail. Editing this video format on a computer is still a challenge, however. And you must be diligent about archiving copies of your video if you value your work. You'll be amazed how quickly these video files will start getting lost on your computer if you don't stay super-organized.

> **TIP:**
> Be sure to check what type of memory card the camera uses and figure in the cost of buying additional cards based on the number of minutes of video it can record. Trust me, you'll never have enough cards if you're on a busy vacation schedule.

This type of video storage is also a highly compressed MPEG format, such as MPEG-1 or MPEG-4. This format most likely has a small frame size of 320 x 240 or 640 x 480 pixels. Carefully check the specifications. Sure, this video is acceptable for placing on your iPod or your phone, but it's not ready for prime time if you want to create quality movies or record important events to share with others in a quality that goes beyond what you see on video websites.

DIGITAL MEDIA VIDEO CAMERAS

Video camera manufacturers are competing to combine digital video and still photography capabilities into one affordable camera. As camcorders become smaller and their CCD chips develop higher resolutions and smaller power requirements, the art of combining movies and stills into one camera is becoming a reality. This development is being fueled by consumers, many of whom grew up with broadband cable, high-powered computers, and simple software such as iMovie and iChat. Websites like MySpace.com and YouTube.com are filled with images and movies made with these cameras.

What does this mean for you? If your goal is to make high-quality, usable video for either family or professional needs, stay with a dedicated video camera.

If you're absolutely set on a hybrid camera, however, there are several new models on the market you should check out. For example, the Everio GZ-MC505 by JVC shoots a 5-megapixel still image, has a 3-CCD video chip, and stores up to seven hours of MPEG-2 video at DVD video quality on a 30-gigabyte hard drive. Video and stills can also be captured and transferred to a computer via its SD (secure digital) memory card.

This is one example of a hybrid camera with promise. In this fast-changing camera market it is a smart investment of your time to search the Web for evolving trends and technologies. For the immediate future, however, I recommend you keep your video and still cameras in separate compartments in your camera bag.

VIDEO CAMERAS WITH HARD DRIVE RECORDING

There was a time when only computers had hard drives. Now, with incredible miniaturization, a new line of tapeless camcorders containing hard drives with capacities of 60 gigabytes or more can record MPEG-2 video straight to the drive, bypassing tape altogether.

The length of shooting (recording) time varies with the capture-quality settings and hard disk size, but upwards of 14 hours of video can be obtained with these cameras, even set on the highest quality. The greatest feature of this type of camera, though, is the ability to review your footage in the camera. There's no waiting time to rewind a tape and review your work. You can also make room on the camera's drive by deleting scenes that didn't work out. (As with any information stored on a hard drive, be very careful you don't delete more than you planned.)

The downside with this type of camera is that you need to stop filming when the hard disk is full. Sure, that's not a problem if you're near home or near a computer. But it could be an issue if you're off the beaten track or you are on a tour schedule that requires constant location changes.

One solution for archiving your work from a hard drive is to burn DVDs as backup. For 14 hours of video,

this can require more than 13 disks and a lot of time. To my mind, Mini-DV tapes are simpler to shoot and store, and even though they might get dumped into a drawer with no identifying labels, you'll at least be able to find them where you left them.

HIGH-DEFINITION VIDEO CAMERAS

Disregard everything I've said previously about being wary of new formats and storage devices for your video. Something many of us have been waiting for has arrived on the scene and it's called HD, as in High-Definition. It's just as important and exciting as the first digital DV camera that could download and duplicate quality video to a computer through FireWire.

Most of the cameras I described in the earlier sections use either one or three CCD chips to record their video. Their video image size is either 640 x 480 or 720 x 480 pixels. These camcorders deliver wonderful quality but their output just doesn't play well on the new flat-panel IIigh-Definition televisions. HD televisions work well when they display a 1920 x 1080 pixel image. When you display a video image that has 4.5 times more resolution than DV, it's stunning.

Lightweight high-end video cameras are bringing the world to us in ways we've never experienced, from cameras strapped to the backs of dolphins to performers wearing them while onstage.

Sony's line of prosumer High-Definition cameras has made professional-quality filming available to the consumer.

These consumer HD camcorders collect their video either one frame at a time—which is called a "progressive" scan camera—or by shooting two frames each at 1/60 second and interlacing them. These cameras are sold as either 720p or 1080i video HD formats. That number stands for the top-to-bottom frame size in either progressive or interlaced scanning. The resolution and color from these new HD one- and three-chip cameras are breathtaking. The image quality is somewhere between that of 16mm and 35mm film. The camera I use right now—a Sony three-chip—captures a 1440 x 1080i image in the new HDV compression scheme.

There are also palm-sized HD cameras and though they can't compare to the more expensive models—where lens quality and features reign—they're really good. I took one with me on a filming expedition to Nicaragua and Guatemala (see a sized-down version of this work at www.americanlandscapegallery.com). Upon returning home, I edited the footage in Final Cut Pro Studio and viewed the work on a new 40-inch High Definition LCD-screen television. For less than $8,000, I was able to create a film with the quality of a film that required almost $100,000 a decade ago, once I tallied the equipment, the film, and the editing suite time.

Apple's iMovie and Adobe's Premier Elements for Windows now even offer entry-level versions of their high-end editing programs for HD. With the recent release of HD-DVD and Blu-ray recorders and players, there's a way to share and distribute your HD works of art in full resolution. Why is that important? Well, anything over 20 minutes of HD video will not fit on a standard DVD. To play back this technically beautiful footage at its full resolution on HD TV required a platform other than the camera to play it on. Sure, you can record back to tape and hook your camera up to the TV, but what if you want to send this off to Hollywood?

Because HD is a new format, it does require a certain investment of time and money to master. You'll need to explore the quickly changing models of cameras and you'll need to have the fastest computer with lots of memory and excess hard-drive space. You'll also need to put some time and study into the editing and sharing of your HD work.

FEATURES, AND HOW TO CHOOSE THE ONES YOU NEED

Most of today's digital camcorders—regardless of their formats—look alike. Many of them have the same buttons and functions, many of which the professionals think are useless. But there are a few functions that I deem a necessity.

Accessible controls on your camcorder will facilitate your need on occasion to override the automatic settings while you are shooting.

The most important feature on a camera is the simple ability to override built-in automatic features. As you move beyond the point-and-shoot approach to your photography, you'll want to operate the camcorder manually. That means you—not the camera—control exposure, focus, and camera stabilization.

When you become proficient with your camcorder, there will be many instances when you will want to override auto-

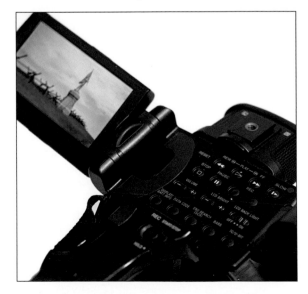

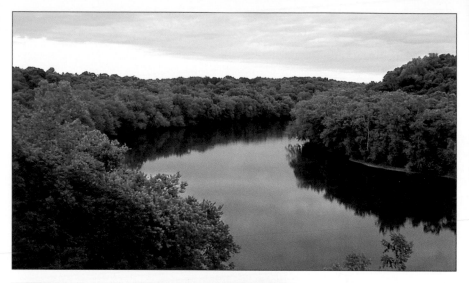

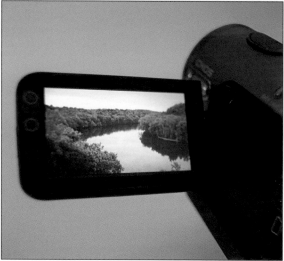

I captured this still photograph on a one-chip High-Definition camcorder. I set the exposure manually while I was filming.

focus, for instance, because you can't get the picture you want. Here is one example. You have set your camcorder on a tripod at the end of a dock on a foggy morning to film blue herons skimming the surface of the water for breakfast. On auto-focus, the camera can't decipher which is more important—the haziness of the atmosphere or the movement of the heron. The camcorder pulses in and out searching for a focal point. This is where the anticipation of the problem and turning off the auto-focus becomes an important part of your camera technique.

The other important feature to control is the auto-exposure mode. Auto-exposure is a very handy tool that will usually deliver an adequately exposed clip. When natural light levels darken, however, the camcorder will automatically boost gain (exposure), which can create unwanted noisiness (pixelation) in your image. At first

you'll be amazed that the camera seems to add light to a relatively dark room. The trouble develops when you might actually prefer to keep the light low and moody. Lighting and how you apply it to your shooting style is one of the most important elements to a professional-looking video.

Zooms

Another important feature that manufacturers love to embellish is the zoom capabilities of their cameras. There are two key words to look for when buying a camera with zoom capabilities: optical and digital. Optical zooming means that all the magnification of the image is done by shifting the lens elements to a zoom factor somewhere in the 10x to 25x range. It is strictly a physical function of the lens. This is the preferred type of zoom capability.

Digital zoom is electronic hocus-pocus. When you employ it, a portion of the image is enlarged through the addition of false pixels. These are mathematical computations, not optical, so what you gain in a close-up shot you really lose in huge amounts of image quality. I would rarely use it.

Sound

Sound is another very important element of your video. Take a moment to see whether a microphone can be connected to the camera. This requires a shoe attachment on the camera that accepts a microphone (or a light) through the standard adapter and an input to connect the microphone. Some models can now bring the sound from the external microphone connected through the camera's shoe on top of the camera. This is the place normally saved for connecting an external light. If there are no microphone inputs or shoes to hold it, you're stuck using the in-camera microphone. That is not necessarily a bad thing.

Using my new Sony HD camera in Central America, I didn't have time to work with an external microphone, and the sound from my video camera's internal microphone was amazing. Most of the early camcorders I've used had poor-quality internal microphones that would pick up all kinds of unwanted external noise, including the sound of the camera's tape transport system. If you

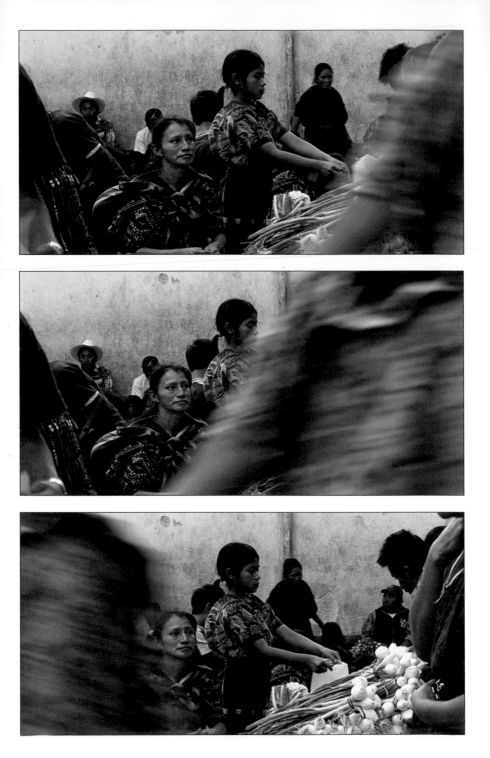

were in a quiet room it was likely you'd hear the camera churning away.

Today, video cameras with flash memory avoid the tape-drive whine, yet internal microphones can still pick up the camera's focusing and zoom motors. Every little movement of your hand on the camcorder also transfers to the microphone. The worst offender is the video camera's strap or lens cap flapping in the wind, which is overlooked by most beginners until they show their video with that annoying clacking sound running throughout. Most video camera microphones are susceptible to even the slightest amount of wind noise, and this can render video sound useless.

If you're going to spend a lot of money on a camera or plan to be paid to capture an important event, the ability to use a shotgun or wireless stereo microphone to capture sound can be the difference between having a usable video clip and wishing you had made that extra effort. A small shotgun microphone is a must for gathering important sound elements such as wildlife, ambient or background sounds, conversations or dialogue. A shotgun microphone is long and narrow, and its focused zone of sensitivity allows you to collect sounds from the direction you point it while avoiding or reducing unwanted sounds from other

Focusing your camera manually will help you avoid a shifting focus in your video when someone or something passes in front of the camcorder lens. Mastering this skill is a big step toward a more professional-looking video.

Bad sound will ruin your finished video. Additional equipment such as this shotgun microphone (top) or lavaliere microphone (bottom) can help minimize extraneous noise.

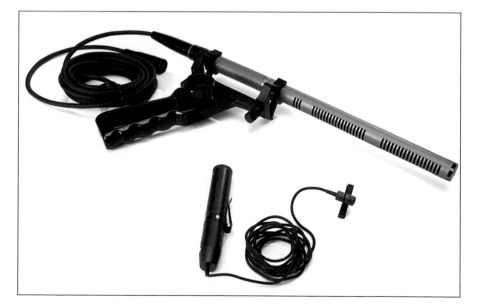

directions. With the addition of a windscreen and noise-damping handle, the resulting quality and clarity of sound will greatly improve the final video piece and eliminate hours of surgical audio corrections in the editing process.

Another important sound accessory to consider is the wireless microphone. A wireless microphone is extremely helpful for gathering close-up intimate sound such as speeches, wedding vows, or anything else where you can't be shooting right in the middle of the scene. If you need to record clear discernible sounds and spoken words, either a shotgun or a wireless microphone setup is necessary.

A wireless microphone system consists of a microphone transmitter to be connected on or near the subject and a small receiver that is plugged into the sound input jack of the video camera. Some cameras allow you to plug the wireless microphone into one of the stereo channels and plug a second microphone, such as a shotgun, into the other. That gives you the luxury of cutting between two types of sound sources, or mixing them together for depth and effect.

Before you go out and spend money on additional microphones, you need to be aware of what type of microphone connectors or input connectors your video camera allows. Consumer camcorders—if they have microphone inputs—primarily come with two kinds of connectors.

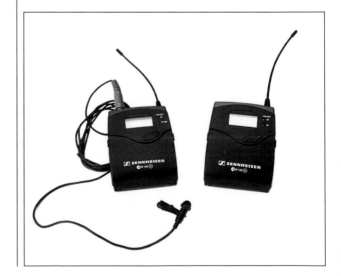

A wireless lavaliere microphone (left) and the accompanying receiver that fits on the camcorder can help you move around without the hindrance of cables and distance limitations.

The less expensive cameras use the mini-jack, the type of plug earphones used with iPods, CD players, and such. The higher-end DV and HDV cameras use professional three-pin XLR connectors. An XLR connector is a more substantial plug and provides a balanced-line input that helps cancel out hum and other line noise, especially if the microphone cable is run over long distances.

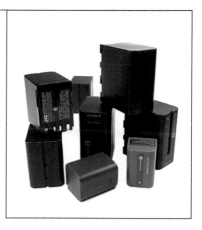

Still Photos

Many video cameras now have impressive still photo capabilities. Everything else equal, this element of still-image photography on a video camera could be the tiebreaker for you. Need a still photo quickly for the e-mail you have to send out from your hotel room? I know I'm going back on my initial judgment about keeping still and video cameras separate, but for an all-purpose camera, this might be worth considering.

Batteries are available in different capacities and sizes. Sticking with the brand names that are specifically manufactured for your camcorder is a small investment to guarantee compatibility and warranty issues.

Auxiliary Lights

I'll go into more detail about lighting later, but as you decide on a camera, just remember, additional lighting is often necessary for shooting quality video. Nothing's worse than realizing the event you are supposed to be filming is in the black hole of some windowless hall. Here's where a bit of extra light will make all the difference. It won't be pretty, but you'll get the shot.

With that in mind, remember that most cameras have a shoe on the top of their housing to receive an accessory light or microphone. One of these small video lights will cast a usable and often scene-saving light, but like using the built-in flash on your still camera, this basic flash will give you that "deer in the headlights" look. At a minimum, you should have a small light for dimly lit situations and evening shots.

Night Vision

Another lighting feature that has a limited function but is useful for certain occasions is a camcorder's night vision capability. You've all seen those eerie green images on television news programs from situations when the videographers didn't want to draw attention

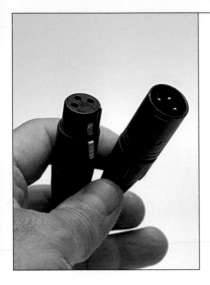

Be aware that some sound gear and external microphones often use XLR connectors. Many camcorders use only mini-plugs for external microphones. A conversion adapter is needed but it may not be an acceptable physical connection.

to themselves with bright lights. In this mode, the camcorder emits infrared light that is not visible to the eye but allows the camera to record a video image in total darkness. Sure, the image is grainy, green, and high-contrast, but for certain subjects or moods it's another feature that is occasionally useful.

Battery Life

We live in a world of rechargeable battery-driven components. Power is the single most important aspect of shooting video. In the past decade, battery technology has advanced considerably. I once had a battery pack for my 3/4 Ikegami video camera that weighed more than four HD video cameras combined. That battery pack allowed me to use the video camera about seven hours less than just one of the small batteries I use today.

If you don't have adequate battery power, you can't capture video. So when selecting a camera it's helpful to look at the camera's standard battery size, weight, and camera "run-times." More important, if you plan on shooting your weekend ski trip in frigid conditions—which lowers battery capacity—be sure to buy and carry extra batteries. A small 12-volt inverter for the boat or car is also extremely handy for recharging on the road.

Optical Image Stabilization

For the person who only handholds a camera, there is an imaging aid called "camera image stabilization." This feature has the potential to greatly reduce the shake in your handheld shooting and save what might otherwise have been a collection of useless clips. I'll go into this with more detail in Chapter 3, but if you choose your video camera with this feature in mind, you need to know that there are a couple of image-stabilization types for consumer cameras. These are optical and digital stabilization, and the difference is not unlike the difference between optical and digital zooming. Optical stabilization floats lens elements optically to keep the image centered or steady, while

digital stabilization moves the image after it's been digitally captured, using pixels outside the frame as a buffer. Generally speaking, optical is superior to digital stabilization, but they both should be used selectively. Familiarize yourself with your video camera and learn how to quickly shut off this feature.

Connectivity and Computers

If you plan to edit video on your computer, you will want FireWire or USB 2.0 data ports on the video camera from which to download your video onto the computer's hard drive. Be aware that FireWire connections are called by many names but look for IEEE 1394 compatibility. This is the industry standard for FireWire connectivity. If you're thinking about buying a video camera with a hard drive or flash memory, you'll still need to download digital data to your computer. I'll warn you now that an old computer with small memory, no FireWire port, and a small hard drive will sap all desire out of your video editing attempts. Software and computers change just as rapidly as video cameras. Be prepared to upgrade your computer if you want to buy the latest gear. And check the compatibility requirements as well.

For steady sweeping landscapes—especially when using the telephoto setting—a fluid-head tripod is a necessity. Notice the windscreen (the gray fuzzy cover) on the microphone.

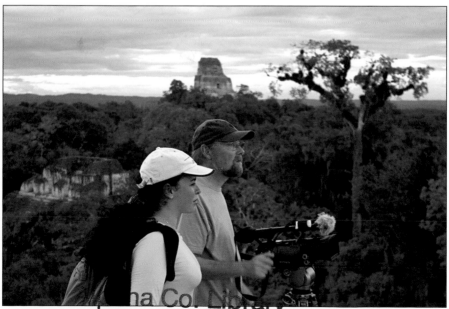

Most people steady their camcorders with their hands. Image stabilization has made this more acceptable, but the reality is that most handheld video is too shaky to be of much value outside of your own patient viewing.

A FEW WORDS ABOUT FLUID-HEAD TRIPODS

A decent tripod can be one of the most important and useful accessories in your kit. It's one of the quickest ways you can move your video program from amateur to professional quality. One of the worst offenders in home video is the "shaky camera" syndrome. Certainly lots of documentaries and movies are shot "handheld," but when you see a scene in which the camera pans a landscape, a fluid-head tripod is probably underneath the video camera.

Fluid-head tripods differ from ordinary still-photo tripods because they are designed for smooth camera movements that are slow and steady as you move the camera left to right (panning) or up and

down (tilting). They don't catch or jump like a still camera tripod will, and most provide an adjustable tension on the drag. But even if you don't pan or tilt the camera, a good tripod will give you a steady, viewable capture.

You can spend more on a fluid-head tripod than on your camera, so be sure to shop around. You're ahead of the game if you have a store that stocks several brands. Reviews on the Internet can be helpful, and remember the number one rule: you usually get what you pay for. If you buy through the Internet, find out what the restocking fee is in case you don't like what you get. You might even figure that expense into your budget if you expect to try and return several models because you want the tripod that feels the best. It's also very handy to have a tripod that comes with, or can use, a quick-release plate. When you're shooting video, you want to be able to quickly disengage from the tripod.

When shopping for a tripod, remember, weight is a major consideration. Search out the smallest and lightest tripod rated for your camera and possibly one that has carbon-fiber legs. If the tripod is too heavy and unwieldy, it's unlikely you'll drag it along to use it when you should. Other important features to look for are a ball head and bubble leveling. When you set up your shot for a pan across the countryside, you'll need a level tripod to make a smooth horizontal pan without your camera ending up pointing to the sky. A ball head with a bubble-centering float allows for one quick centering action that makes for an easy, level shot. All this sounds a bit much, I know, but a tripod with all these features—lightweight, ball-leveling, release plate—is something you'll truly appreciate.

CONCLUSION

As you finalize your decision on a camera purchase, remember that it's not how much money you spend on a camera that makes a successful video but how much thought and effort you put into your work that will make the real difference. If you understand your camera and use good shooting techniques along with your best creative effort, the work will pay off with a video that you and others will enjoy watching.

PRODUCING IS ABOUT CONTINUOUS LEARNING

While James Barrat was out in the field with his crew making the documentary *The Gospel of Judas*, he was the shooting producer. In this role he directed the crew, the cameraperson, the soundperson, and the associate producer. He checked the monitor after every take to ensure they were getting what he needed. And when the budget for the crew ran out, Barrat picked up a camera and shot some B-roll footage himself.

"Like so many in this business, I started out doing something other than television production," explains Barrat. "I was a playwright in Washington, D.C., and a colleague asked me to help him write a television script about tank warfare for the National Geographic Society." The producers for that film recognized that Barrat had a natural ability to write for for television.

During the next few years, Barrat wrote other television scripts for National Geographic as well as The Learning Channel. The writing led to some production work, a path that is not a common one. "Some come into producing by photography," says Barrat. "Others start as editors and maybe that is the best route. But writing scripts is also good because you know how to build a story, piece it together, and make a show with continuity."

His work has taken him around the world creating episodes for the *Explorer* series and he wrote the script for the acclaimed *Lost Treasures of Afghanistan*. For The Discovery Channel he wrote and directed *Intrigue in Istanbul*, a one-hour documentary. For UNESCO's World Heritage Series, he made three films about places in China.

Barrat maintains that the most important part of his job is the constant process of research and learning. It helps him create a script structure and it also helps him to find situations to film when he scouts a location before the crew arrives. "If you don't make that effort to learn everything about your story, the people you end up working with know almost immediately how much of an effort you've

James Barrat (left) looking at the video monitor on location during the filming of the documentary GOSPEL OF JUDAS.

given the story and that makes a big difference, trust me," says Barrat.

"You really become a perennial student," he adds. By studying and applying himself to each story, Barrat has had the chance to spend time with top-notch thinkers in fascinating parts of the world. "I always try to give each story the best effort, and the day I stop being amazed about the stories I work on, I'll hang it up."

Shooting Your Video

3 | *Shooting Your Video*

One of the interesting qualities that separate humans from all other animals on our planet is our insatiable need to reflect upon and record our lives. We often express this proclivity through the creation of visual narratives in photographs and videos. If you were granted access to these collections, you would see a story of families with their loved ones, their interests, and the places they have been. It's all there waiting for future generations to discover. But what particularly strikes me about these collections is that if you took all these visual moments and stitched them together from house to house, city to city, country to country, you would appreciate how vast and powerful this visual narrative is and how important this process of taking pictures is to our well-being.

What has so dramatically changed today is the way we now look at and share our moments and memories. The days when the family sat together on the couch and looked at the photograph album have probably passed, or almost. More than likely, the family of today and tomorrow will be sitting around the flat-screen television watching Uncle Mitch's Africa trip downloaded from his laptop, or niece Merici's piano recital shot that afternoon on Mitch's new High-Definition camera. Today, with online video mailboxes and picture repositories, family or business events can be shot in one moment and shared around the world in the next. Society has moved to a new level of visual communication with super-large Internet bandwidth and fast, powerful computers, and all available at a relatively low cost. High-quality video is now a reality for the average person, and the limitations are really only up to you.

There is one thing that hasn't changed with all this technological advancement: good photography still requires thoughtful and proficient camera work, and dedication. It is no simple matter to organize and edit your video, either. You still have to learn the craft.

I know you can do it. This new world of digital video is too exciting to ignore now that you have the automatic settings to get you started. So take this book, sit down, and begin to learn the fundamentals. You will be making more professional-looking video in no time.

Make sure you bring lots of batteries with you when you pack your digital video camera for an exotic vacation.

Shooting a video is like building a house one board at a time. Make a plan before you shoot the local high school football game so you will have the variety of shots you need later in the editing process.

STARTING A VIDEO MIND-SET

First off, shooting video is different from pointing a still camera and taking a picture. To use a simple analogy, shooting video is like building a house—you do it one piece at a time. Initially, the piles of lumber, plywood, and siding have no relationship or structure. In the builder's mind, however, there exists a plan. The construction process is complex, and often frustrating, but gradually the house takes shape, and the builder's vision is realized. The same pertains to making a video. The mechanical process of shooting and editing can be complicated and tedious, threatening to sap your creative energy. "I only want to take pictures, I don't want to be a computer geek," you say.

I understand. At first, it's a rough ride. Thinking about how and what you want to shoot—which means paying close attention to framing, sound, action, and lighting while also keeping careful watch on battery levels, filters, tripods, microphones, and all the other bells and whistles on the camera—can be confusing. This is especially true if you pick up your camera just occasionally. The challenge in shooting video, as in all photography, is dealing with the technical elements while staying focused on the "creative" big picture. The simple truth is "practice makes perfect" and shooting good video to tell cohesive stories is no different.

Since computers with creative editing tools have entered the scene, there's the temptation to think, "I'll correct the problems later when I edit the video." The fact is, "garbage in, garbage out" holds as true today as it did when computer programmers first stressed that a computer's output is only as good as the original input. It's true, you can correct some problems with sound-, contrast-, and color-balancing tools, but the goal in this chapter is to show you how to prepare for and guard against these problems at the source, so that later you can concentrate on editing a technically strong video. The aim is for your video to grab everyone's attention as they gather around the new family flat-panel TV or assemble to watch the company's "eye-opener" at a conference.

PREPARATION

As you might have figured out by now, I'm trying to get you to a place you might not have intended to be. This

book is designed for those who want to go beyond the occasional video event and really learn how to use these magnificent new tools in this modern age of digital photography. With that in mind, there are two things you must do before you go out and shoot your first video epic or family event.

The first is simple: Get to know your camera. The second is to mentally organize yourself for the subject matter you're going to photograph. The front-end investment in time spent learning the technical and creative aspects of videography will help you toward a successful and satisfying video shoot. As you will see, there are many levels of the visual narrative that video embraces, and therein lies the challenge and the excitement.

KNOW YOUR CAMERA

If you're sitting there with your new video camera just out of the box, the first step is to familiarize yourself with all the little features that attracted you in the first place. Face it, most of us resist reading the manual and want to start shooting immediately. I admit I am often in this category. So, if you must, go out with the camera's settings on "automatic" and shoot some video. Trust me, though, if you don't take time to familiarize yourself with this new feature-filled camera, you might never fully understand it. Even simple functions, such as switching between recording and viewing modes, confuse a lot of people. Many of the camera's features can be hard to find, too, and once you've found them, you may not know when they should be changed or turned off. It's too late to figure it out and begin recording when you're at your friend's retirement party.

At first, you might not want to change anything. Eventually, though, you'll need to sit down and learn how to take full control of your camera. So let's begin this process by learning how to activate or turn off features such as image stabilization and why you might even want to shut them off. Next, let's understand the importance of setting the white balance, and follow that by understanding why you might want to switch between automatic and manual focus. Finally, let's check the audio settings or at least discover where these settings are buried in the complicated menu screen.

Many of the new video cameras are menu-driven through their touch screens. Sure, this is a nice feature, but often it is not very intuitive. Trying to navigate through layers of screens to shut off auto-focus, for instance, especially under stressful shooting conditions, can be slow and confusing.

One simple rule to follow is to keep your video camera's manual or cheat sheet with you at all times. Believe me, even seasoned professionals become overwhelmed with all the buttons and screen menus. You don't want to find yourself halfway up the walkway to Mount Rushmore only to realize you can't remember how to open the camera to change tapes or discover that the camera accidentally got switched to "night vision" and you can't figure out how to shut it off.

THE BASICS

For simplicity's sake, I'll boil down the actual process of shooting with a digital video camera into two basic styles. The first approach is to pull your camera out of the bag and begin shooting in what many call a "run and gun" style. You go with the moment and don't worry about clip lengths, continuity, or style. You pan and zoom, sometimes excessively, and the final video has a style similar to someone putting out a grass fire with a garden hose. This is part of the "fast cut" world of video where the camera never stays on its subject for more

ESSENTIAL THINGS TO DO BEFORE YOU START YOUR FIRST SHOOT

1. Read the camcorder's manual or refresh yourself with the controls before you go.
2. Set the camcorder's audio (if you can) to 16-bit, 48kHz quality. This will be very helpful in the editing stage.
3. Learn how to shift from manual to automatic functions and back again. Make a little crib sheet with these steps so you can pull it out for quick review. Know how to set everything back to automatic when you're totally flustered.
4. Bring enough tapes, DVDs, flash cards, and batteries. Everyone skimps on batteries because those little lithium-ion batteries are expensive. It's very embarrassing when you're out of battery power in the middle of your daughter's recital, I can assure you.
5. BUY EXTRA BATTERIES AND TAPES!

than a split second. At one point, this style said "Amateur" with a capital *A*. But surprisingly, or maybe not so surprisingly, popular video websites are filled with this style, and professionals are even adopting the style when appropriate. What an unusual turn of events!

As you've probably guessed, the second basic style is much more deliberate. It begins with a thoughtful plan of the scenes you want to shoot before you begin. Learning to be instinctive, while still working from a game plan—however rudimentary—and editing the final film down to a tolerable viewing time should be your aim, whether you practice "run and gun" or plan a methodical, well-organized shoot.

The goal for the rest of this chapter is for you to develop some basic but established camera techniques. If you pay close attention to some simple technical issues while also being creative and steady with the camera, the editing process will be much easier down the road. You'll also see it in the response from your audience.

Be sure to spend time with your camcorder before you begin an important trip or shoot. You need to know how to toggle between automatic functions and manual controls.

The beauty of these new digital video cameras, regardless of shooting style, is that all you have to do is turn on the camera, use the automatic settings, and shoot. The camera will do the focusing, perform white balance, and adjust its exposure. Sound levels will be adjusted to the situation and protect against overmodulation. Yes, these camera functions have been around for some time, but the speed and accuracy of these adjustments have greatly improved over the last few years.

However, many situations can't be photographed well on the automatic settings. The camera cannot adjust to your liking on its own, sometimes. These situations come in unlimited varieties, but mainly surface with unusual framing and focusing techniques, lighting that is subtle or difficult, or where you're trying for

special effects with different shutter or lens settings. Often, the only difference between an average-looking video and one that draws you in, is just a matter of controlling the camera beyond its automatic settings. So be brave and switch your camera from "auto" to "manual" and follow me through the rest of the chapter.

CONTROL THE CAMERA

A videographer needs to develop at least four levels of camera control. The creative challenge is that these levels might demand your attention simultaneously. This is where your creative and technical skills combine and, with time and practice, become second nature to you as a videographer. So, what are these four levels?

1. Control the basic settings: control the light levels entering the camera by changing aperture and shutter-speed settings; change a camera's white balance for a desired look; learn how to focus the camera manually and/or turn off image-stabilization controls.
2. Work with the light: use light to enhance the video, including working with and understanding natural light; know when to add light and of what sort (soft or hard light, fill light); work with an unusual color balance.
3. Capture sound: effective use of on-camera sound and external microphones; know when to record "wild tracks" to enhance the sound.
4. Shot or story awareness: tell your story using creative angles and perspectives along with interesting framing; use pans, tilts, and zooms appropriately; think about story continuity and camera direction when filming action.

The first step in becoming a confident videographer is to get comfortable with turning off the automatic con-

Understanding the impact of white balance can often yield more pleasing results in your video quality. In automatic mode, the camcorder adjusts the image for average light and balance, settings that can lead to very average-looking video.

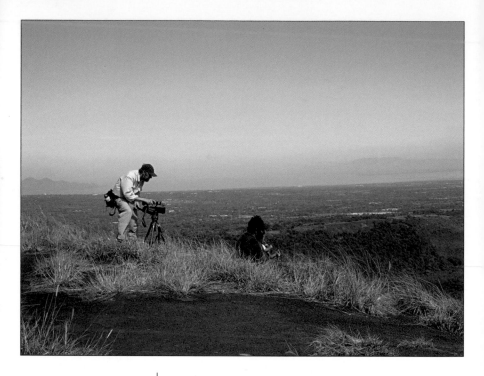

When I was making this sequence for my film in Guatemala, I had many decisions to make: composition, depth of field, shadow exposure, the type of tripod. I also had to be very careful about the sound quality, given the very high winds.

trols. For example, you're trying to focus on the early-morning view from the deck of your room on Lake Louise. You set up your tripod and begin a nice, slow pan across the lake when suddenly the camera loses its focus on the shimmering water. The shot is ruined and you have to start all over. Not a big problem unless that wonderful formation of geese came into the shot. If the camera is on manual focus, you alone control it. You'll feel more professional, and, besides, you've spent a lot of money on your camera and this trip, so why not come back with some of those special moments that are fleeting and beautiful?

APERTURE, SHUTTER SPEED, & GAIN

Aperture, shutter speeds, and gain are the three controls you need to master in order to affect the light values, or levels at which the video camera will record its data. The aperture setting controls the light coming through the lens. The shutter setting regulates how long the video frame is open to the image passing through the lens. The "gain" is the additional signal processing the camera applies to the video image.

If the camera is in automatic mode, it will decide this for you. But the goal is to learn how to manually control these three functions and value levels of the final image. If you grasp this on the first reading, move to the head of the class.

Understanding Aperture

So let's start by exploring the manual use of the camera's aperture. The aperture is an interior part of the lens, usually circular, that adjusts or limits the quantity of light that passes through the lens to the camera's imaging chip, or sensor (either the CCD or CMOS variety).

Automatic aperture control is often satisfactory for average settings where lighting conditions are fairly constant. But what if someone with a white shirt walks into the frame, for example, or daylight from a window is creeping into the shot? These changes will affect the quality of your picture. A camera set on automatic will adjust to this lighting situation and possibly affect the video's exposure by underexposing or overexposing the shot.

Other situations in which you might need to control the camera's exposure are night scenes or scenes with artificial lighting. Let's say you've turned down the lights for your daughter's birthday cake presentation. What you want here is a video that captures the mood of the birthday party in the dark room full of giggling kids lit by the candles on the cake. Now you're looking for the glow on her face as she blows out the candles. With the video camera on "auto," it comprehends, "This scene is too dark, give it more light." Most likely the camera set on automatic will open the iris to the maximum and then add gain to the image, creating an unnatural, noisy image. Manually controlling the aperture allows you to

Some camcorders, such as this JVC High-Definition camera, place their manual focus and aperture controls on the side.

adjust the exposure so you can maintain that exposure on the candles and faces and not let the camera expose for the whole room, making a more washed-out image.

One simple technique for determining the best exposure in situations like the birthday candle scene is first to frame the scene with the camera on "auto" to see how it looks on the camera's display. Then switch to manual and close the aperture down until you get nice detail on the candlelit faces.

Where's the Aperture Control?

Some video cameras have an aperture wheel on the side. Some have the aperture ring on the lens, while some of the new palmcorders use their touch screen for changing all the camera's settings. Those touch screens are cool, but they can be a nuisance when you're trying to make adjustments quickly. Take a few minutes to locate the aperture control on your camera and learn how to turn it manually.

Shutter Speed

Most still cameras have a shutter—a mechanical device that opens and closes, regulating the time that light is exposed on the film or sensor chip. Shutter speeds are set in fractions of a second, such as 1/15, 1/30, even 1/2000 second or more. A time exposure opens the

Good lighting and proper exposure is a great way to make your video more professional. When the camcorder is set on automatic below, the camcorder adjusts for the darkness of the room, resulting in a washed-out tone to the entire image.

shutter for periods as long as minutes or hours, if you wish.

Today's digital video cameras are different because they regulate their shutter speeds by electronically controlling the length of time a chip registers a signal for each video frame.

The most important impact that a shutter has besides regulating light level is the amount of sharpness that each video frame maintains. The amount of image movement for each video frame is called motion blur and can greatly affect the look and feel of a video.

Hollywood movies are usually shot on 35mm film stock at 24 frames per second (fps) and since this is a relatively slow shutter speed, each frame has a certain amount of motion blur. In other words, one frame blends more smoothly into the other, giving this filmic look. Most video, though, is shot at higher shutter speeds—1/60 second or faster—and will render any action as a crisp image. This is that "video look" that some photographers love and others hate.

If your camera allows it, try keeping the shutter speed at 1/30 second and let your aperture wheel be the controlling factor for setting proper light value. You might have to have a couple of neutral-density filters in your kit if the existing light becomes more than what your

TIP:
To focus with small hard-to-see LCD screens, zoom in on the subject, focus, and then zoom back to the desired framing before you begin recording.

Switching the camcorder to a manual exposure allows you to close the aperture a bit so the candles don't overexpose the whole image, yielding a more realistic-looking scene.

TIP:

For easy-to-forget screen menus, or steps, create a written cribsheet for quick reference. For example: "To Change Exposure: menu screen > exposure menu button > on or off > exit by return button."

aperture setting can stop down on. If you have to, set your camera back to "auto" where it will adjust shutter and aperture speeds. I know this is a bit much for most people who are only interested in gathering good video of their daughter's graduation. But for those who want a special look to their video, slower shutter speeds and a more shallow depth of field will help take the hard edge off your video image. This method might even give you ideas of other subjects you would like to shoot.

Gain

Some cameras also apply automatic gain control that boosts the video signal when the signal or light levels fall below a certain value. Other cameras allow you to apply gain manually to give a boost to the scene, but usually at a price in image quality. In either case, this is why the camera seems to record in very low light levels. It is electronically amplifying the weak signal. This adjustment in gain is defined in decibels (dB). A +3dB setting is adding twice the power to the video signal; with +10dB, 10 times the original signal power is being applied.

As in everything, you can't get something for nothing. When the camera adds gain, it also adds noise by only adding a boost to the image signal. Remember the old days when you used fast film? You gained a stop or two with this fast film, but you also picked up lots of noise. Most professional videographers will not turn up camera gain, but will add light or reposition the subject or work with the dark image. But rules are made to be broken, right? Looking at the pumped-up gain and oversaturated colors in some videos today, it seems anything goes.

DEPTH OF FIELD

One of the characteristics of these small digital video cameras is their extreme depth of field in normal light. Everything appears in focus from close-up subjects to distant vistas, creating a sharp, flat image. Visually, this can be very boring.

The next time you go to a movie or watch a DVD, see how the shots have a much shallower depth of focus. Here, the director focuses the attention on the subject

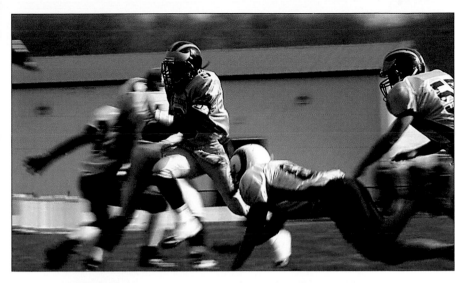

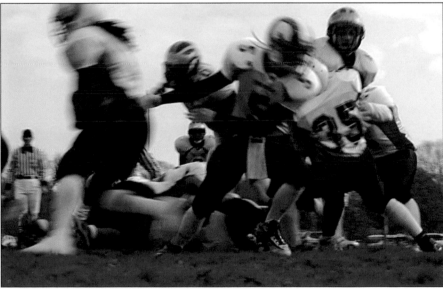

while maintaining an out-of-focus background. This technique of "selective focus" used by filmmakers will give your video a more professional, filmic appearance. But how can you achieve this when the camera automatically balances the light with a small aperture setting that results in a large depth of field?

One way to do it is to manually open the camera's aperture, reducing the depth of field. As you might have

Using a faster shutter speed makes better sports pictures. Compare the "bright sun, fast shutter speed" option (top) to the "lower light, slower shutter speed" (bottom) to see which effect you like.

guessed, this will increase video exposure beyond acceptable levels or move your shutter speeds too high for your taste. The easy solution is to use a neutral-density (ND) filter over the lens. Neutral-density filters screw onto the front of the lens. They come in various densities, so it helps to have two or three different densities in your kit for various lighting conditions. There's some variation between manufacturers, but the filters are usually designated as 2x, 4x, and 8x, which is 1-stop, 2-stop, and 3-stop light reduction, respectively. More

At a nighttime pool party, I preferred to let the iridescence of the pool light stay as it was by not using the white balance to average the lights in the scene. You can also experiment with your camera's night-vision capabilities if it has it.

expensive video cameras have ND filters built into their lens system, for ease of use. Your camera's manual will give the millimeter (mm) diameter of the lens. You'll need to know this if you order a set of ND filters.

WHITE BALANCE

Our eyes automatically adjust to the various light sources we live under, so we are rarely cognizant of the warmish light that incandescent lights give off at night, or the colder bluish light of a high-noon sun. The effect

A shallow depth of field (bottom) with the use of neutral-density filters (ND) can often yield more pleasing results. When you watch your next movie, look at how most filmmakers employ shallow depth of field in their filming.

that shifts in color from daylight (bluish) or fluorescent (greenish) or incandescent (yellowish) light sources have on a subject will affect the look and color balance of your video. Most of today's digital video cameras attempt to correct these color shifts by using the automatic white balance feature. The goal is to seamlessly correct every type of light source to a neutral white and provide consistency to the color balance of your video.

Yet for all the sophistication of these digital cameras, they can miss the mark. Most professional videogra-

phers do not leave anything to chance and use a white card to manually balance their camera under varying lighting situations. There is a button on many of the more expensive cameras that you can press while you're focusing on the white card. This sets the whites so there is no major shift in tone other than neutral.

If there is one generalization I can make about professionals, they usually want to warm up their images. Flesh tones, the greens of trees, and interior shots are more pleasing if they have a warmish cast to them. The adjustment can be very slight, but it makes a difference. One trick on the smaller cameras is to manually set the camera's white balance (WB) setting to "cloudy"; it will warm the tones, making for a nicer image. Also, many cameras allow you to go in and add yellow or blue to your setting in increments, giving you control over how warm or cool you make the overall image.

Another example of when you might not want the camera to automatically balance the light of a scene to neutral white is that same candlelight birthday party I used in the aperture section. The goal is to preserve that deep warm yellow from the candles and the glow on the people's faces. Just by controlling the exposure and white balance, you can turn a shot from normal and flat-looking to rich and full of depth.

So, learn how to manually override the automatic white balance feature and experiment by warming or cooling the color of the video image to your liking. Always keep in mind, if the image looks average and normal, it might also be very boring.

IMAGE STABILIZATION

Raise your hand if you like carrying a tripod around. Gee, I don't see many. The truth of the matter is, no matter how strongly I might argue for the use of a good fluid-head tripod, most of you are going to ignore me. So let's go to my second choice, "image stabilization." Most likely it's one of the features on your new camera. So what is it, exactly, and how is it used?

There are two types of image stabilization: optical and electronic. Optical stabilization, found on higher-end cameras, uses a dedicated lens element that shifts its position based on the camera's motion in relation to the

The manual controls of a Sony prosumer High-Definition camcorder are on the side. On the bottom is a quick-release plate so you can move your camcorder quickly from tripod to handheld smoothly.

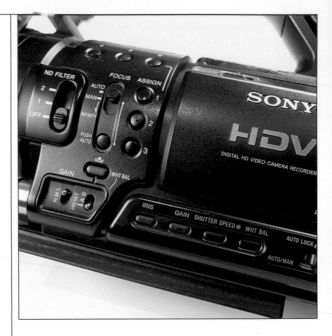

This image has a warm tone that is often preferable to cool blue tones. Try to balance the color of your video in the camcorder rather than in the computer.

subject you're photographing. The goal is to dampen camera shake. Because this is done optically, there's no loss of signal quality other than creating a somewhat spongy feel when you're shooting certain subjects.

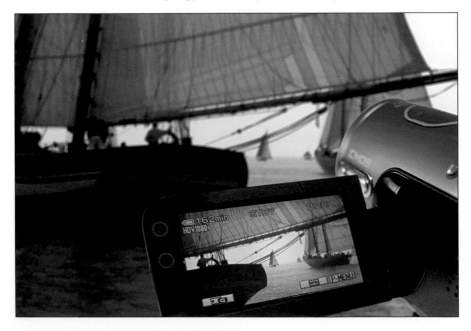

On the flip side, "electronic image stabilization" captures the video image into a cache before it's recorded and shifts the captured image in small degrees to minimize camera movement. This function works best in well-lit situations but be aware that when your video camera has to stabilize excessive camera movement electronically, degradation of the images can occur. If you are using a tripod, find the button or screen menu to turn off the electronic stabilization function. If you're panning on a tripod, for example, that image might make a funny soft (i.e., blurry) landing at the end of your pan. Or if you're focusing on a foggy or low-contrast scene, the image stabilization might cause some issues as it searches for a hard point to stabilize on. Generally, the rule is to turn it off during the time you use a tripod or in low-contrast situations.

WORKING WITH LIGHT

Lighting is a very complex and extensive subject when it comes to video. But let me touch on the basic elements that can give impact to your video without turning you into the "gaffer" or "chief lighting technician." The primary goal when the light levels are low is to prevent adding signal gain (the camera's electronic boost to the

This image is too blue. Experiment with the white balance setting to find the tone you like.

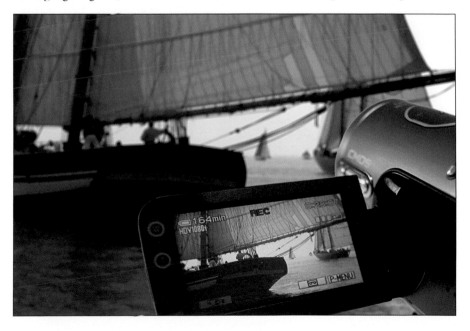

image signal, which usually adds image noise to get an acceptable shot. The better solution is to add light to the scene. Also, if your goal is to shoot night street scenes, we want to prevent the camera from trying to turn them into day scenes by adding gain. We have talked about this before in the birthday party example.

If you do use lights, there's one rule I stress. Do not use your light on the camera unless you want that flat deer-in-the-headlights look. You see this a lot on TV news where the cameraperson has no choice but to clip a light to the camera in "run and gun" shooting style. But if you want texture, expressive shadows, and mood, a key light off to the side can really help. You might also have to place a fill light on the shadow side of the subject to balance the stronger key light. Of course, this requires an investment in a portable light kit, and this certainly depends on the type of subject matter you're going to shoot.

Most of us will not be hauling lights around, so paying careful attention to natural lighting and how to use it effectively is a more practical part of capturing quality video. Video, as compared with film, has a difficult time with high-contrast midday sun. The high-noon sun creates impossibly harsh shadows that must be filled in with some sort of light (either reflected or from accessory lights). Also keep in mind, daylight color balance is affected by time of day, cloud cover, and physical location of the subject. A person standing in the shadow of a deep green forest, for instance, may have a greenish cast. Pay attention to shadows and color balance. Most of the auto white-balance features will get you to a neutral white, but is that what you want?

Most professional still and video photographers are religious about trying to shoot early in the morning or late in the

If you plan to work alone during filming, strong but light carbon fiber fluid-head tripods are essential.

HANDHELD SHOOTING WITH IMAGE STABILIZATION

Using a handheld camera with image stabilization still requires steady camera technique for it to work effectively. A few simple steps will go a long way toward making your video from your handheld camera more professional-looking.

1. Hold the camera with both hands, even if it's small. If you use the same technique a person uses with a handgun on the range, you'll have strong, steady camera work. Breathe slowly. If you're holding your breath, take a deep breath, then let it out just before you start shooting. This works great if you are taking 10- or 15-second clips. Anything longer and you'll need to take a breath.

2. Stand with your feet apart, slightly wider than your normal stance, and with one foot back and the knees bent just a bit. This will lessen the tendency to fall backwards while you're holding on to a shot. Keep your elbows tucked in to your torso.

3. To help steady the camera, you can also lean on something—a table, a wall, or tree. Or lie down in the prone position. This low angle can make for an interesting viewpoint. Anything that minimizes your camera shake is worth trying.

4. Using the camera at its wide-angle setting rather than the telephoto setting will reduce the normal human handheld shake. Telephoto work only amplifies camera shake and usually requires a good tripod.

5. Planning your camera moves can also lead to smoother handheld techniques. Decide where you want to start your shot and where you want to end it. Practice the move if possible. Planning ahead can help you avoid an amateurish video clip that ends and suddenly starts up again in a different place.

6. Follow the shot or keep recording until you feel you've made a complete statement or the action has ended. This shooting intuition will develop as your technique improves.

7. One of the big mistakes made when filming people is turning off the camera while someone is talking. Let all sentences be completed, if possible.

8. For scenic shots, let the tape run five or ten seconds minimum, and much longer. You can always edit clips to the length you desire, so why limit yourself on the gathering end? Remember, tape and memory cards are the cheapest part of the production, so don't be afraid to use them.

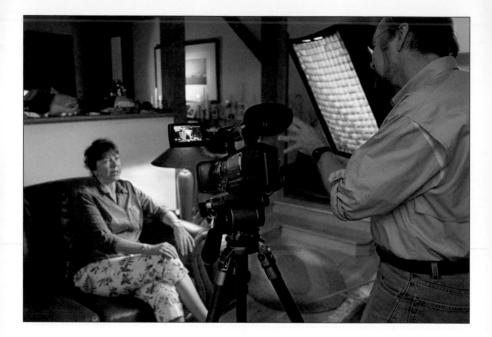

Simple lighting kits, such as a soft box with an egg-carton baffle, can create soft key lights during interviews and the like. Also, moving your subject into a well-lit location is worth the effort.

afternoon, during those "golden" times of softer light, saturated colors, and interesting but not impossibly deep shadows. These qualities go far to enhance the look and feel of a video.

If you find it necessary to use supplemental lighting, there are lots of lighting kits available for sale or rent. There are also foldable reflectors with a metallic coating that can bounce light onto the subject. Keep a watchful eye on hot tungsten lights placed too close to objects. They can easily char a wall or start a fire. Also, allow plenty of time for them to cool; I've burned my hands more than once working in haste.

Another thing to keep in mind is that lighting changes throughout the day, making it more difficult to edit segments together that have been shot at different times. So what are some of the items one might take on a lighting setup?

1. A typical transportable lighting kit consists of tungsten or halogen lights that fit on collapsible stands, have heat-resistant hoods that reflect the light, and have add-ons like baffles that focus light just on the subject. Many photographers improvise by going to the hardware store and rigging up their own lighting kits. Those little hot-lights made for the top of the

camera do their job, but the light quality is terrible.

2. Several large spring-loaded clamps found in hardware stores are handy for hanging curtains, backgrounds, or other items that need to be held in place.

3. Large pieces of poster board or folding reflectors are great for filling in shadows. Cheesecloth or translucent sheets of plastic can also knock down the harshness of light falling on the subject through windows. Do not use them on tungsten lights unless they are specifically rated for those hot temperatures.

4. Gaffer tape, similar to duct tape, won't leave a residue on your aunt's dining room table. Always be careful when applying tape so you don't pull off finish, wallpaper, or paint when it's removed.

5. Extension cords. If you're lighting a scene, you can't have enough long cords. Buy quality cords and be sure you tape them to the floor with gaffer tape so no one trips. If you're a one-person show, be sure the lights are placed out of the way, taped down, and away from curtains or just about anything else. A simple lighting scene that tips over and hits someone on the head will quickly change the mood of your shoot, if not worse.

SOUND

It's generally known in the film and video industry that an audience will accept a certain amount of imperfection in the video image. When it comes to poor-quality sound and unintelligible dialogue, however, audience acceptance levels drop way off. Once you start shooting and editing your video, you'll immediately realize how important a good sound track is to your work.

You need to develop sensitivity to the various levels and qualities of sound. No distracting sound is too small. For example, if you're listening to a speech and the air condi-

Portable reflectors can help bounce light into the shadowy areas of your subject, as seen in the top image.

Using a key light with a reflector (the white card at right) can add depth and balance to an otherwise dull scene.

tioners are running, more than likely you won't even notice. The human ear picks through the mish-mash of sounds and focuses on what it wants to hear. But the camcorder's microphone is another story. That little air conditioner in the corner can ruin your shoot. Unwanted sounds from airplanes, wind, machines, and people will provide you with some of your biggest challenges to shooting professional-quality video with a clean sound track. So here are some basic steps you can take to help make good audio, which is so important to a good video.

First, invest in an external microphone (providing your camcorder has an external connection). Most serious videographers use a small "shotgun" microphone that has a narrow angle of audio sensitivity toward the direction it's pointed. Some microphones can attach to the camera's hotshoe located on the top, usually. There are clip-on lavaliere microphones that either connect to the camera by cable or send the audio signal back to a wireless receiver attached to the camera. The nice thing about external microphones is that camera noise made by the camera operator's hands or breathing is less likely to affect the sound.

The best and cheapest solution for good sound is to get nice and close to the subject, especially if you need to capture wedding vows or the speaker's main address. Being close in, though, creates certain problems. Be sure to check with your subjects and inform them of what you intend to do. It really pays to come early to a shoot, make friends with those in control, and assess the sound and camera positions way in advance.

When practical, turn off any overriding noisemakers such as ice machines, fans, and air conditioners. The best option would be to tape a wireless microphone on your subject or to the lectern if you want professional sound recording in a large space.

Most professional videos have additional layers of sound placed into the edited scenes along with the original recorded sound. Most of these are sound effects or sounds collected at other times, such as wildlife, wind, water, ocean waves, or crowd noises. Many sound effects can be purchased on CDs or downloaded from websites, but the most satisfying and fun are the ones you record yourself.

A good example of recording extra sound might be ambient crowd noise that you can use under many of the shots you edit from a trade show, or background crowd noise at a wedding. This layer of wild sound helps smooth out the chopped sound you will encounter during your edits. It's a good idea to spend a few minutes at your shooting locations to collect background sounds, either with the camera or with an audio recorder.

A furry windscreen wrapped around the microphone mounted on a camcorder can make the difference between usable and unusable audio.

Audio Recorders

Back in the days of reel-to-reel recorders, editors had to splice tape and sound technicians had to lug heavy units around to gather good sound. With these new, light-weight digital recorders, the process of gathering additional sound has never been better or more fun. The choices range from MP3 players, DAT (digital audiotape), and Mini-Disk, to flash memory recorders, which all of which make for easy sound-file transfers from recorder to the computer.

By using an external recorder at the speaker's podium, you can move around the room shooting various angles and details of people and later sync the recorded speech to the video portion during the editing process. I'll get into that in the editing chapter.

A wireless microphone is often the answer to getting good clean audio from an individual, especially if you are interviewing them while they are working.

SHOOTING THE STORY OR EVENT

So here you are with your new digital video camera and you're ready to begin to capture a story or event in video. Or better yet, you might just want to noodle around and have some fun taping the subject of your interest. Who knows where this might lead?

Whatever your desires, you have to begin somewhere, so the first thing I suggest is to take yourself and your new camera to someplace new and different for the day—a place you've never been before. You need to break out of your daily routine and experience this place through the lens of this exciting new camera.

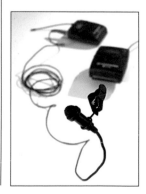

Remember to always capture some wild or ambient sound when you're on a shoot. You'll need it later during the editing process. This shotgun microphone has a windscreen and a sound damping handle and it is connected to a digital flash-card recorder.

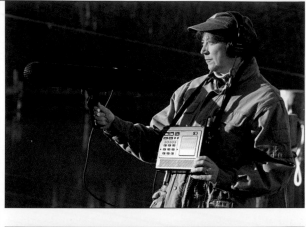

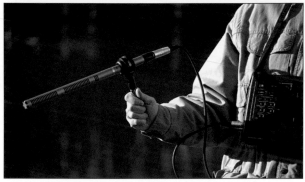

A change of scenery, whether near or far, will inspire you to see things from a fresh point of view. It might be a good idea to go by yourself, without the distractions from family and friends. Once there, listen to the sounds, sense the movements of nature, look at interesting compositions and framing, look for interesting colors or anything that you can use to interpret your surroundings. Try different settings on your camera. As you're filming, say out loud what settings you're using so the camera will record the information. Later, you can review the video to check what you were doing.

Start looking at scenes in short segments, the way most movies or documentaries are shot and woven together. It's like working with building blocks. Start to build something on a theme. It's this process of looking at the world in shots or clips, often no longer then a few seconds long, that begins to condition your way of seeing the world as a filmmaker does.

Try your hand at covering an event such as a business meeting, a corporate presentation, a birthday party, or a wedding. Whatever the gathering, you should keep the approach simple.

How to Tell a Story

So what are the approaches to telling a story? First, keep your eyes and ears open and approach the situation like a still photographer looking for a good picture or moment. You should be looking for interesting moments where composition, lighting, movement, and sound all play important parts. Sometimes the action is obvious, such as someone speaking or blowing out candles; other times, you will need to hunt for moments of interest. This is where your style will develop with the unique way you see and react to these movements and moments. These small pieces you gather in your video camera will later be stitched together into a story that has a beginning, middle, and end.

Start by setting the story location with a series of establishing shots. Where are we? In the beginning of any movie, the director is trying to set the location and mood of the story. Is there a unique way to establish this location or give some new reality or perspective to the sequence of events that will follow? Establishing the video can be a series of short clips or long, elaborate sequences that run for minutes before the title even runs. Practice by taking wide, medium, and close-up shots of the place.

Next, who are the people involved in your story? Is there some way to establish what one might expect later in your piece? Again, practice by taking wide, medium, and close-up shots of the people.

Be alert for interesting sounds and comments being made. People love to ham it up for the camera and often say hilarious things. Do not cut people off in the middle of a sentence. Ask questions from behind the camera so people speak easily toward the lens and the microphone. For an interesting exercise, spend a few moments with your eyes closed and listen to sounds around you. How might they help your video? Try watching a film by turning off the sound. Watch just the editing process.

TIP:
Remove or secure your lens cap and camera strap. Nothing says "amateur" more than the sound of the strap or cap hitting the camera on a windy day.

Keep your video moving along in a logical progression. By its very nature, an event such as a party, wedding, or trade show is relatively easy to film. Each has a beginning, middle, and end. You only have to use your creativity and let things unfold in front of the camera.

Once you have captured all the obvious elements in front of you and on the surface of the story, the next logical step is to capture the behind-the-scenes activity. Whatever the event, there will be people arriving, meeting each other, showing expressions of warmth, etc. While you're following one situation, such as the arrival of guests, you must also be keeping your eyes on the main subjects as they prepare to begin. You're probably saying to yourself, "I can't be in two places at once." Well, you're right. The challenge for all photographers is making spur-of-the-moment decisions as to what is the most important subject to be shooting at any given time. This is where experience will help, and if you're exhausted by the end of the day you've probably done your job.

A good photographer learns early to always keep moving and not invest too much time with one subject or shot unless it specifically requires it. Deciding how much time to spend on a shot depends on the story.

Shooting with confidence and developing a strong, steady, and thoughtful style is your goal and will make your work in the editing room that much easier.

Style

When you think back on important films you've seen, you probably remember the story and not the camera techniques employed. As unique as most stories seem, many of the camera techniques are not. They are tried-and-true techniques. A camera in the hands of a master is what makes the difference. Just keep in mind, the most important style you can develop is one that doesn't get in the way of the story.

Scenes

Videos or films are built on a series of scenes, and each scene is built by editing together a group of shots. These shots combine various camera positions, camera angles, audio segments, and lighting interpretations that create a scene when pieced together. Each shot can be a micro-second or uninterrupted footage that runs for many minutes. There are no rules.

Shots are a combination of wide, medium, and close-up views. Wide shots help set the context of your story and place the viewer in a location. From wide shots, the camera or segment moves in closer to the subject with mid-range shots to give emphasis or direction to your story and subject. Next, the close-up brings intimacy, impact, and a sense of forward movement to the storyline.

Being fluid and steady with your shooting, using these various wide, medium, and close-up shots should provide the pacing and emotional energy to keep your video

INSPIRATIONS FOR RICHARD

1. Hollywood classics such as *Citizen Kane, It's a Wonderful Life,* and the *Lord of the Rings* trilogy
2. The 100 list created by the American Film Institute
3. The video *Baraka*
4. The Soviet masterpiece *Man with a Movie Camera*
5. D. A. Pennebakers's cinema verité style in the documentary *Bob Dylan: Don't Look Back*
6. www.pbs.org/pov for current and past listings of exciting new documentaries
7. www.YouTube.com

A wide shot of the mountainous landscape establishes my story about Guatemala.

Another wide shot from above informs the viewer we are entering the town.

I used a tight shot of these dancers to familiarize the viewer with the people and their culture.

engaging. Don't be afraid to experiment with unusual framing and angles. One of the best techniques is to take a moment between shots and study the situation. Think about what you've shot and be watchful for situations going on around the main action that might make a good cutaway.

What Is a Cutaway?

Have you ever said to someone, "I'll be right back?" This is the verbal form of a cutaway. The visual part is a shot that provides a transition or "poetic" pause, which can help you or the editor move from one scene to another or from one shot to another within a scene. In my mind, you can never have enough good cutaway footage. This type of video or film is called B-roll, video to be used later to intercut into the primary footage.

B-roll shots come in handy when your camera gets bumped and you need to interrupt the sequence. Another example is if you want some good crowd reaction shots to intercut into a speech you are filming. The trick here is to keep the camera running so you record the speech from beginning to end. Later, try for shots that can be edited in during the speech.

If you want to go from a wide shot to a close-up of the speaker's face, you'll need to add a cutaway later to

cover the time it takes you to quickly zoom in to the speaker's face and focus. Remember, leave the camera on so you have a continuous segment of the recorded speech. When you get into the editing process this will not be so confusing.

Many professionals believe you can save almost anything in the editing process, but a video's rhythm and creativity really has to be captured in the shooting. Excessive cutting and overzealous camera movements only cover up weak camera work and weak storytelling.

Continuity

Continuity is a real challenge even for the most experienced cameraperson. But there are some obvious rules you should begin to follow. Make sure your subject in a scene, for example, isn't wearing a red shirt one day and a blue one the next. Trying to edit this together is impossible. Is someone holding the water glass in her left hand and, in the next edit, holding it in her right? Not all viewers will catch this, but you will. To make your video believable, the continuity, or physical integrity, of the scenes must be maintained.

Having someone on your team to help with continuity can save you future headaches. The videographer's

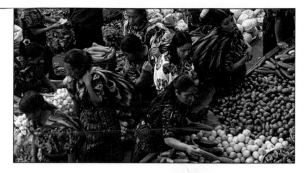

During a transition, I used this medium shot to show the rich colors of Guatemala.

Use different angles but be respectful and obvious when you work close to someone.

Capturing daily life can augment your story by putting a place in context for the viewer.

goal is to keep the story visually active and moving forward. If you're shooting a planned event, the continuity of the video exists within a natural beginning-to-end passage of time and makes the editing process somewhat easier than a video project stretched over many days.

Crafting a video based on a concept or story where the subject's time does not pass in an orderly sequence requires a great deal more planning. Are there flashbacks or large jumps in time or changes of season? If your video project is that complex, you'll need to develop and religiously follow a storyboard or outline that is a scene-by-scene depiction of how the video is to be shot. As in any long journey, you need to chart a course.

Each day of shooting you should have your ideas and needs written on an index card. At the very least, you should have a basic shot list. Don't forget your camera's crib card with settings, suggestions, and steps. Who can remember the steps to shifting white balance when you have a dozen people waiting on you?

As always, plans are only a guide that will need to be changed along the way. Don't compromise on your vision just because it wasn't in the plan. Look for and be ready to tape that unplanned moment. Those serendipitous moments are the shots that will set your video apart. Lots of people claim professional photographers are lucky. In reality, the pros make their own luck.

Continuity of Movement

Moving or cutting between action shots can be disorienting unless a few basic rules are followed. If you're photographing your son's track meet from the bleachers and runners are moving from the left to the right as they pass in front of you, you have established a direction of travel through the video frame.

If, in the same sequence, you cross over the track during the race and take another shot as they come around, they will now be moving from right to left in the frame. Now your son appears to be running in the opposite direction. The 180-degree rule states that you should consider the path of your subject as a line. As long as you stay on the same side of the line and do not cross over

180 degrees or that line while you film this particular action, your shots will maintain reasonable continuity of action.

This rule also pertains to people talking. The line that connects the two people provides the visual mark, and as long as you stay on one side of it, it won't appear as if the subjects have reversed positions. Staying on one side of this line allows all your cutaways and close-ups to have visual logic. If you switch sides without a necessary transition, viewers can become lost in your story.

I often map a story, however rough, to keep me focused on the shots I need to make. But be flexible. Stories constantly change.

Maintain Eyelines

There are subtle details that can help or hurt your video's credibility. If someone in your video has wandering eyes, he or she will appear distracted and awkward, and everyone will notice. If you're interviewing someone, be standing slightly off-camera so the subject looks at you and not directly into the camera. Follow the 180-degree rule when dealing with your subject's eye-line, just as if it were an action line. On the other hand, look at Errol Morris's Academy Award–winning documentary *Fog of War* in which Morris employed special mirrors that enable the interviewee, former Defense Secretary Robert McNamara, to appear to be speaking directly into the camera, which he is not. It's very strong, and Morris's unusual visual approach shows how rules can effectively be broken.

Continuity of Lighting

For shooting a documentary, wedding party, or any other spontaneous event, you have to use available lighting. Occasionally you might add some fill-light if it gets too dark. But if you're doing a training video, a special feature, or a series of interviews for money, pay close attention to the quality of light and try to keep visual uniformity over the course of the project.

Watch for the changing direction of sunlight and shadows. When you're editing later, and the shadows on a desk or a person's face suddenly change from frame to frame, it will definitely be noticed in the video.

ZOOMING AND PANNING

There are a few other rules that will keep your video from looking amateurish. First, do not zoom back and forth excessively with the camera running; you'll only make your audience dizzy. If you're going to use the zoom during the shot, it should be done slowly so as not to draw attention to the camera itself, which is hard to do. If you look at the way many films are edited, the intercutting of various camera angles and positions creates movement between shots. Cutting between wide, middle, and close-up shots can achieve this, especially if you change your position for each shot.

When you use the zoom to change your camera view or position, you can either edit the zoom out later

or stop the camera, zoom to the composition you're looking for, and then start the camera up again. Make sure you give yourself enough time to make a proper edit later.

If the sound is important to the shot, as it almost always is, it might be necessary to leave the camera on as you reframe the image. Later, you can use a cutaway to cover up the position change while the sound continues. If you're doing landscapes, you have a lot more latitude with adding or fixing sound later on in the editing process.

If you pan the camera, do it slowly and steadily. Here's where a fluid-head tripod really comes in handy. If you do not use a tripod in panning, it is especially important that you plan out the beginning and end points of your pan so that both start and end smoothly. Planning your shot allows you to position your feet and body so you can end the pan without falling over or getting a muscle cramp. You do not want to interrupt the pan once you've started. If you're following a subject, such as a dancing wedding couple, the action is leading the pan and is visually more interesting and full of energy. Keep your eyes open for similar movements that can give interesting energy to your video.

Do not use your camcorder's zoom because you're too lazy to get out of the car. Use your zoom only to compose between different shots.

PLAN A SHOOT

So, what does planning ahead mean? There are many levels. Take the simple approach. You want to shoot your son's football game from the bleachers. You must: check the batteries and charge them if necessary; make sure you have enough tapes or other storage media; and pack your camera bag with some lens-cleaning tissue and fluid, and possibly a clear plastic bag in case it rains.

The more important part of preparation, and often the least prepared, is the mental plan. This is nothing more than giving a little time to thinking about what you are going to shoot. Interesting video doesn't just happen. Let's take the football game. What are the parts you love about going to the game? Sure, you love to watch your son play, but there's more to this game than just taping him running up and down the field. What about the people in the bleachers? In the parking lot? On the sidelines? These other elements of the story/event are the pieces that go into storytelling and will make your video interesting. Create a wish list that will help you visualize a series of images you might not think of photographing while you are there. It's a mental exercise to help you create a well-rounded story using snippets of video rather than words.

BASIC PREPARATION LIST

Here's an important checklist for your video shoots. Naturally, your specific needs might require more or less than this list suggests.

1. Purchase either a hard or soft case to protect your camera during transport. Make sure it fits under an airplane seat.
2. Have spare batteries, at least double the time you'd expect to shoot.
3. Charge all your batteries!
4. Check that you have lots of videotape or memory capacity. Double the time you think you'll need.
5. Pack your tripod. Nothing's worse than shaky video.
6. Do you have at least one neutral-density filter? Either a 4x or 8x. Having both is ideal.
7. Prepare a list of objectives. It never hurts to spend a few quiet moments and mark down what interests you or what you think you should shoot.
8. Research your subjects well.
9. Pack your camera manual.
10. Reacquaint yourself with the camera's manual controls.

Here is a sample list of items I created before I went out to shoot a football game:

> **TIP:**
> Keep your eyes open and be ready for the unusual. Serendipitous moments can be the meaningful and zesty bits that make your video unique.

1. What does the overall stadium scene look like? What are the sights and sounds that typify autumn Friday nights?
2. What are the things that happen before the game? At the foodstand? In the stands?
3. What are friends and family doing? Throw out a question for someone to answer—"Say, Bob, what do you think are the chances your daughter's team is going to win?" Let him speak. You can have a post-game question for the same man or woman.
4. Make sure to get variety in your action shots. Capture the game action, in wide shots and close-ups. Maybe try to get down along the field for your best action shooting. A tripod might give you better results, but you have to be fluid and handhold the camera. If it's a night game, make sure you have the exposure issue down in advance. You might have to get there an hour early to work these things out.
5. The postgame reaction is a good source of material; try for a mix of close-up, mid-range, and wide-shot coverage.

You can shoot these elements almost as if you were doing still photos, but include enough time to fill out a scene. Use an occasional slow pan or follow a group walking. Action always helps, and as you develop an eye and feeling for the video flow, strive for spontaneity by keeping your ears and eyes open. What might sound dull on paper depends entirely on how you carry yourself and shoot your video in a crowd. Get into it, be friendly, have fun, and think about your list of shots.

Okay, I understand that was a long list and many of you probably wanted to shoot just a few moments of your kid's game. Still, there are those of you who will approach this as if you actually were doing a documentary for the ESPN channel. Either way, what I'm trying to define is how much rich material there is at a simple high school football game. If your intent is to capture this pageantry with your video, your success will be much greater if you spend a few moments visualizing how you might go about it. That time spent with a pad and paper, planning what you want to cover, is what makes the difference between video and

Keep close to the bride and groom and watch for those special moments.

Create empathy with your subjects so they're comfortable with your presence.

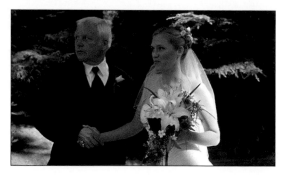

There are always key moments you really should get. Try to anticipate them.

video shot with a goal in mind. Either way, you'll get results, but having a plan will get you there faster and more completely.

A Few Thoughts About Weddings and Business Videos

If you're just getting started in video, you need to be extra prepared for photographing a wedding. Be sure you and the bride and groom have the same expectations. If there's any chance they want a super-polished piece for DVD distribution to the family and wedding party, you need to be forewarned. These expectations will likely include complete coverage of the entire wedding, including the wedding vow sequence, the ring-exchange, close-ups of facial expressions along with the wide-shots of the church event and crowd reactions. Oh, did I forget to mention gathering great sound and good music?

I don't mean to scare you off, but I suggest you start slow and learn all the levels, from planning to shooting to editing, before you put your video work between you and your friends. The same cautionary note goes for when your boss has the great idea for you to produce a short video on the upcoming weekend team-building retreat, with the idea that you can pop it up on the Web or show it at the annual board meeting. I don't mean to under-mine your self-confidence; I just want you to be prepared

and somewhat proficient in the art of making video.

But let's assume you're planning to jump right in taping a wedding or the company retreat. Here's a possible checklist you might construct before you head out the door:

1. Put yourself into the mindset of the wedding or project. What would you like to see? Even more important, what do the bride or your colleagues at work expect to see?

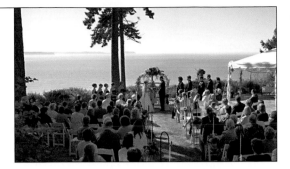

Don't forget the all-important wide shot and scene-setter. You will need it to establish your story.

2. What is the location like? Visit the scene if it's close, or give yourself plenty of time to explore the area prior to the shoot. If it's a vacation, read up on some of the key places you're going to visit and look at the Web to see what others have shot in video or stills. There are good tips to be found.

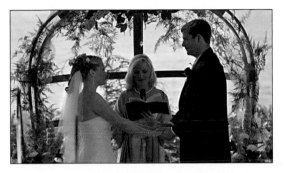

Anticipate where you will be when the key moments happen before the story begins.

3. Prepare the camera and equipment checklist well before the day of the event or wedding. It will be too late to discover you need filters or lights, or that you don't have enough tapes or memory, the day you are leaving.

4. My editors have always told me to shoot lots of film because it is the cheapest

If you immerse yourself in the story, you'll find you can anticipate the meaningful moments.

part of the assignment. With today's digital media there's even less excuse to be spare with your shooting. Shoot everything that captures you or your friend's interest. It's too late once the event is over to wish you had worked harder.

5. Make friends with all those in charge of the event. Everyone will be more cooperative if they have a feel for what you're doing and what kind of person you are. Trust me, investing in the human relationship side of shooting pays off.

6. Find out from the bride or your colleague what it is they would like to see. By understanding the subject or event before you begin applying your own visual interpretation to an event can be a wonderful combination in the end.

7. Check your camera list for last-minute details, and be sure your sound, white balance, exposure, and focus settings are what you want. I've taped an entire exciting day of sailing with the camera set to DV rather than HD by accident.

8. Check the lens element for smudges or dirt. I can't stress this enough. Keep looking at your lens for big specks of dirt, rain, etc. These tiny details can spoil an entire shoot.

9. Do you have enough battery power for the time you expect to be shooting?

10. When recording someone speaking into the camera or people talking, don't shut the tape off in mid-sentence. Later, in the editing process, you'll be thankful for complete audio segments even though they don't make much sense to you at the time. Always keep in mind the importance of a clean, strong sound track.

11. Don't worry about editing in the camera. Shoot, shoot, and shoot some more. Later you'll edit this all down to a tight, concise show.

12. Be friendly, and under certain situations, ask permission to take video if you don't know the people. A smile and a friendly acknowledgment that you've entered someone's space helps immensely.

13. Dress conservatively, don't have gear hanging from every shoulder or belt clip, and most important, keep your eyes and ears open. The most difficult part of shooting among friends is abstaining from socializing during the event. Sure, you want to be friendly and you do want to catch up on the latest news. But a weak video with missed scenes and opportunities will linger much longer than a few missed conversations. Both emotionally and physically you can't be in two places at the same time.

This mental checklist is really nothing more than an exercise to put you in the right frame of mind. The ability to prepare your equipment and visualize your video objectives while maintaining a spontaneous approach to your shooting must become second nature if you're going to take this beyond an amateur status. Have fun, shoot video, enjoy the moment, and be thankful you'll have these wonderful moments to share for many years. At the very least, take one event and apply yourself with this heightened level of photography. See what it does for you and what your results are. You might be pleasantly surprised.

Always remember those filmmakers who came before you. Their techniques can teach you a lot about how to make your videos better.

CONCLUSION

I've thrown a lot at you, and you shouldn't expect to walk out the door and become a polished professional tomorrow. But you will be a lot better the first time out with a few of these principles in mind. Be patient and experiment with some of the techniques. Reread this chapter again if necessary. It will take a while before using your camera becomes second nature and your vision begins to solidify. But even if you see the slightest improvement in your shooting technique, trust me, your friends will see it too.

DAVID LINSTROM

SHOOTING FOR THE EDIT

As a cinematographer, David Linstrom has traveled the world working for ABC, HBO, NBC, and National Geographic. In the field he is always making decisions about how he needs to shoot a story. But he never forgets who benefits first from his work if he does it well: the editor.

"An editor is going to spend weeks on your video when you're done, and if you don't provide good, interesting, and varied footage, they will have a difficult time piecing the story together," says Linstrom, who recently returned from a trip to Chad in Africa.

Linstrom began his career as a still photographer and then he took a television production class. Immediately smitten, Linstrom transferred to San Diego State University where he completed a work-study program that included hands-on work at a PBS station nearby.

"Some people think that you need a real specialization in cinematography, such as underwater work or wildlife," says Linstrom. "In some cases that is helpful. But I feel that in order to do documentary work at a high level, you really have to be curious and involved with people and their culture. Or you have to have an appreciation of the science that you are photographing."

Linstrom shoots with a High-Definition camera now. "Today's tools and cameras are incredibly sophisticated and affordable," says Linstrom. "But that has only leveled the playing field. You have to have technical comfort with your gear and know how it works from top to bottom. And remember, sound is half the show if not more. Bad sound can ruin a production. But your most important job as a cinematographer is to make beautiful imagery and shoot for the edit. That's where you stand out."

Linstrom's advice to starting cinematographers is to edit your own video for a while. This way you can discover the shots you didn't make or hear the sound you didn't record correctly. By seeing those mistakes, you begin to learn how a story can't be told without those missing pieces. If you continually make mistakes, try to go into a shoot with a written list of necessary angles and sound bites that must be done well.

"Always keep in mind that no one cares to hear about the anecdotes or reasons about why you didn't get the shot," says

In Chad, Linstrom's kit included a Panasonic Varicam HD camera, a long lens, a wide-angle lens, a matte box, a tripod, and a set of filters. "I use a polarized filter almost always when outside," says Linstrom.

Linstrom. "If the sun didn't rise, there's nothing you can do about that and no one is interested in excuses."

Linstrom is excited about the future for documentary video and film because of the on-demand capabilities that computer networks and television stations are providing. In the past, a documentary was destined for either DVD distribution or into the film festival circuit once it aired on television. But with multiple cable stations looking for content and websites such as iTunes and Netflix offering backlist titles, documentaries have a chance for a longer shelf life. And more viewers.

Chapter 4
Capturing & Editing

4 | *Capturing & Editing*

There are few limits to what you can do with your digital video these days. You can stream it on personal websites. You can display it in your home. You can even try to sell it.

But first, you probably need to edit what you have shot. For people who love to put puzzles together, this can be their favorite part of creating digital video. For those who like the act of photographing—and not the computer work afterward—this task can be daunting. But here are the facts. Editing can be simple, such as removing the unusable video clips from a weekend trip, or it can be complex. That choice is up to you.

There are some good reasons why you might want to try the more complex approach. Constraints of time can be dramatically altered in your story during the editing process. By combining disparate pieces of video into a form of sorts, you can evoke moods and memories. With the addition of music and titles, you have a complete piece whose sum is greater than its parts. And you'll probably love watching it more than bland reruns.

HOW TO USE THIS CHAPTER
Although the method of editing is similar in using both Windows® Movie Maker® and Apple® iMovie® to create your story, the particulars are different. With that in mind, I have decided to introduce you to the flow of how your work should be approached first. Then, at the end of this chapter, you will find sequential instructions for editing a video in Movie Maker followed by sequential instructions in iMovie.

You may feel tempted to jump ahead right now to learn about the program you have, but you would be wise to just read for ten more minutes. A good overview with some helpful technical tips might save you hours of frustration.

THE SEVEN STEPS OF EDITING
Simply put, there are seven basic steps to capturing and editing digital video. Let's look at them here quickly and then break each one down into detail.

1. Insert your tape into the camcorder and play the recorded digital video.
2. Review clips and import the best video clips into the computer.
3. Create sound and graphics to add to the program.

Think of your storyline frame by frame as you prepare a script.

4. Arrange video clips on the software's timeline.
5. Place video transitions (fades, dissolves, wipes) between elements.
6. Add music, additional audio, and final adjustments.
7. Add titles where appropriate.

REVIEWING YOUR VIDEO CLIPS

The reason most people capture video clips by reviewing them in the camcorder first is to conserve hard disk space. One second of digital video captured in its original quality consumes 3.5MB per second. That's 13 gigabytes an hour! As the cost of hard drives drops, this concern is less of an issue. However, you should get into the habit of taking the time to locate and capture only your stellar work before downloading everything.

If you'd rather download the whole tape, Microsoft's Movie Maker allows you to capture your video in the .WMV format that recompresses your captured video into nearly half the space the original digital video would require. If your intention is to show this video on your computer or burn a DVD, this can be the best choice. If you intend to edit and send your video back to tape, stick with the best capture quality in all your capture choices.

The other important reason to review your tapes for those prime moments is to help with the organization of your project. If you take time to identify the important visual areas of your video and capture these into separate clips, you'll have an easier time moving around your project and shaping it into a story. More advanced editing programs such as Adobe Premier Elements and Apple's Final Cut Pro allow you to preview your video in the camera and log in specific clips by their embedded time code. After reviewing the tape and logging in the clips, the software will control the camcorder and download those video clips at the exact start and stop points you had designated.

In Movie Maker and iMovie, you have to manually capture the good parts if you want to avoid downloading the whole tape. Either method requires a bit of work and

time. But you'll be amazed how fast your editing will progress once you've taken the time to capture and organize your best clips.

TRANSFERRING CLIPS FROM CAMCORDER TO COMPUTER

There are so many variables in computers, camcorders, cables, hard drives, and software, you must physically and mentally prepare yourself for a certain amount of time to solve technical glitches. Whether you use a Windows PC or a Macintosh, the goal is to achieve successful communication between your computer and your camcorder. If you have a new camcorder and a relatively new computer with some horsepower, you shouldn't have too many problems because many of these processes are automated. Whatever setup you have—old or new, PC or Mac—be sure to make notes of your exact process, step-by-step, along with the settings, and put that in a folder for later reference once you have learned to download digital video to your hard drive without dropping frames (losing visual data, making the video appear jumpy). You'll be happy you did!

If you're having any difficulty capturing your video, the first important step is to analyze the computing

Today's camcorders and powerful computers make capturing and editing digital video an almost plug-and-play process. However, prepare yourself for a few problems to troubleshoot when you do it the first time.

strength of your computer. There's no getting around it—you'll need a recent computer with lots of processing horsepower, as much memory as you can afford to install, and lots of hard drive space to capture the video. If you're running Windows XP or the latest Microsoft system release—called Vista—you shouldn't have a problem downloading video as long as your computer has a fast USB 2.0 or FireWire connection. All new Macs using the OS X operating system have FireWire and fast USB 2.0 ports, so you shouldn't have difficulty in connecting and downloading video to your hard drive. The Apple video software program called iMovie HD, included in their relatively inexpensive iLife software suite, is capable of downloading and editing both standard DV and HDV (High-Definition) formats.

The Difference in Formats

As we've discussed, there are many formats for capturing video. Camcorders that shoot Mini-DV tape cassettes are, from my point of view, the easiest to download and edit. These camcorders write their digital information to Mini-DV tape cassettes in a format called DV (an industry-standard compression format of 720 x 480 pixels). Both Windows XP and Mac OS X can easily edit this compression format—called a codec, which is short for compression/decompression—using Windows Movie Maker or Macintosh iMovie. Movie Maker is included in the current Window's operating system, while Apple's iMovie is part of their iLife® package, which includes iDVD®, iPhoto®, GarageBand®, and iWeb®. The iLife package is under $80 and worth every penny of it.

With an explosion of new consumer High-Definition televisions, there has been heavy consumer pressure on camera manufacturers to utilize this new technology. Back in 2003, a core group of manufacturers (Canon, JVC, Sony, and Sharp) introduced a consumer High-Definition video format that had a screen resolution of either 1280 x 720p or 1920 x 1080i. The "p" stands for "progressive," the "i" for "interlaced." At this point all you need to know is that "progressive" means one

TIP:

My Recommendations to Operate Apple's iMovie

- Mac OS X version 10.4.4 or later (or new Leopard due in 2007)
- Mac PowerPC G4, G5, or Intel Core processor
- HD (HDV) requires 1GHz G4 or faster
- 512 megabytes (MB) of RAM minimum
- 250 MB of free hard disk space
- 20-inch Cinema Display or 1280 x 1024 pixel SXGA display
- Apple Superdrive or external DVD burner for making DVDs
- An Internet connection for upgrades
- Microphone and external speakers

complete scan for each video frame, while "interlaced" stands for two fields, or scans, per video frame. HDV also uses the IEEE (FireWire) interface and is in a native 16:9 widescreen ratio. HDV uses another compression scheme—MPEG-2—so it requires software that can handle this.

Apple makes this easy with its new iMovie HD software. If you decide to invest in a more advanced editing program, however, Adobe Premiere Elements 2 and Apple's Final Cut Pro HD both capture and edit video in their native HDV formats. Adobe's Premiere Elements 3—priced for the entry-level videographer—can import video from virtually any media device including HDV, DVD, Web cameras, mobile phones, and MPEG-4 video recorders that use flash memory.

The point to all this tech talk is that before you spend hours trying to download your video from your camcorder or camera phone, be sure you've done your research as to how your devices connect.

Ready to Begin

With your camera plugged into the FireWire or USB 2.0 port, start up the movie software program and name the project with a unique title that will identify the session or project. Next, you want to make sure that you create and name a folder where the captured video clips will be placed. It's very important that you create a routine of naming and placing files of clips and projects in organized folders. When you have hundreds of clips spread out over your hard drive, it gets very confusing if you don't stay organized from the beginning.

Seeing your first edited video on a large television screen can be inspiring.

Most video-editing programs require you to go up to the toolbar to locate the "Capture" function. This "Capture" function opens a window called Device Control that directly controls the camera's ability to play, stop, rewind, and fast-forward. If you're having trouble controlling the camera, go into the program's Preferences and

MY RECOMMENDATIONS FOR CAPTURING VIDEO SUCCESSFULLY

1. Make sure your camera can connect to your computer via FireWire or USB 2.0. Many new computers—especially those equipped for multimedia—come with an IEEE 1394 card installed. If your computer does not, there are a number of third-party cards that will work with it.

2. If you have difficulty getting the camcorder to communicate with the Windows or Mac video programs, check the Device Control settings in the editing program's Preferences. The type of video format and resolution must be set to the same specifications as for the camcorder. If the Preferences are not the same in both, it's as if the computer code is written in English and the camcorder code is written in Portuguese. The devices can't understand each other.

3. If you still can't get your computer to connect, or "talk" to the camcorder, check that the problem is not a defective FireWire cable. In the Windows system, the Window's Control Panel will show you whether the computer is actually seeing the camera. In Windows, go to Control Panel > Scanners and Cameras and see if the camera appears in the display window. If it isn't showing up there, try connecting to another FireWire port if you have one, and exchange the FireWire cable to make sure the one you're using is not defective.

4. Double check that you are using a camera and a format compatible with the editing program you are

using. Adobe® and Apple® maintain camera-compatibility profiles on their websites. If your camera isn't listed as a tested device, there might be hardware-compatibility issues.

5. Use the Web to answer specific camera and software questions or look for possible driver upgrades on the camera's website. The industry has come a long way toward making this process almost "plug-n-play," but some people still find this part confusing.

6. Make sure your video software and computer system software are up to date. This will go a long way in avoiding compatibility issues. If you have old system software, an older computer, and an old video camera, you could have connection issues.

7. A larger monitor with good contrast is a must. I recommend monitor resolution of 1024 x 768 or higher. If your budget can afford it, configure a second monitor. Editing video requires a lot of monitor space for viewing, especially if you get into the more advanced programs. Your monitor should be calibrated using the system's screen-calibration method. This sounds more difficult than it is. In Windows, this can be found in Control Panel > Displays > Adobe Gamma. (Adobe Gamma is automatically installed if you have Adobe Photoshop Elements or the CS series installed.)

8. I recommend that you have Adobe Photoshop as one of your software components. Adding stills to your

When buying a camera, make sure your computer has compatible connections.

video can be an interesting part of your program.

9. Install as much memory as you have room for and can afford. I recommend memory of at least 512 MB (1 gigabyte for HD) or more and a large 300-GB hard drive to capture video and store projects. You can get by with a smaller hard drive, but an external drive reserved specifically for digital video is ideal. The drive should be connected by FireWire or be able to transfer data where video capture is smooth and without any missed frames. This is also possible using USB 2.0, which has a data-rate transfer of 400 MBps. DV video writes to a disk at 3.6 MBps. At that rate, you can take up more than 12 gigabytes of space on your hard drive for every hour of digital video. Of course, the computer needs additional working space when you're editing, so you can see why the biggest hard drive you can afford is absolutely necessary.

10. At the very minimum, make sure you have the movie software included by Windows or purchase iMovie for the Mac. If you can, you should invest in the most recent version of Adobe's Premiere Elements or Apple's Final Cut Express HD. This will initially set up your editing system at a level that won't impede your creativity.

11. The next step is to plug your camcorder into the FireWire or USB 2.0 port of your computer and start up your movie program. Be sure your camera is set to play the recorded video (usually labeled "VTR" or "VCR" on a DV camera) and is visible to and controllable by the movie program. Once you master the process of connecting the camera, communicating with the computer, and downloading video to the hard drive in a named folder, write down these important and successful steps. Keep them in a folder on a desktop for quick reference.

change the Device Control settings. This change might solve the problem.

As you start reviewing the video on the monitor's preview screen and see sections you want to capture, click Start Capture and at the end of the segment of good video, click Stop Capture. You've just downloaded a video clip that will reside in the folder you've named and chosen on your hard drive as the project's clip folder. Continue this process for the whole tape.

Develop a naming concept for your tapes and clips so you can easily identify what the source tape contains. I use today's date or the date the video was shot. If it was 1/12/07, I label the physical tape 011207. If you have more than one tape, add an underscore and sequential number, e.g., 011207_2. When you are logging clips, the reel or tape number is assigned to the file, and you will always have an instant reference to the original tape. Once you have hundreds of clips and many tape cassettes, you'll discover that having a system will preserve your sanity.

After capturing all the clips you want, close the Capture window. Now you should see all your captured clips sitting in the Project window ready to be dragged into the editing Timeline window.

As you review clips, look for those that tell your story. Avoid shaky, out-of-focus, or poorly lit subjects. Keep your standards high. This is where you learn from your mistakes and begin to formulate how you might edit your piece and possibly plan how you might fill in those holes you now see.

Another Word About Advanced Programs

The editing concepts are the same in the pro versions of Adobe® Premiere® Elements and Final Cut Pro® HD by Apple® and these programs allow you to log and batch-capture clips. They also retain and show the original timecode for each clip. By doing this, the program allows you to add keywords and descriptions so you can organize your clips automatically into desired folders. When you're working with hours of tapes from different locations and times, this is invaluable.

Capturing Analog Video

Even though this is a book about digital video, many of us have important video on Hi8 or VHS that we want to preserve before their magnetic signals fade into oblivion. For

a relatively small amount of money, you can buy a video converter that will take the analog signal from your camcorder and digitize it to your computer's hard drive where it can be edited or burned to a DVD or CD.

Your new digital video camera might also serve as a converter. You might be able to record video from your old analog camera or VHS machine directly to your new camcorder. Look to see whether your digital camcorder has a round S-video or a Composite video (yellow marked ring of the RCA type) input and will record signals coming into it through that connector. Simply connect and play the old camcorder or VHS while inputting the signal into the new camcorder in the record mode. Try recording a short segment and see what you get before you invest a lot of time in this. Remember, not all digital cameras accept input from outside sources, so check your manual before proceeding.

Be aware that more advanced programs offer more choices in the editing process.

EDITING

NLE—or nonlinear editing—is the preferred method of editing today. With your captured clips as the main ingredients, you can create a timeline of clips layered with music and sound that will eventually become your finished digital video. You can't really make a mistake. You can go back to other clips with the click of a mouse, increase or decrease edit points, reorder a clip's location in the timeline by simply dragging the clip to a new position, overlay music, or delete a boring scene altogether. The edit controls are instant and endless, and there is no winding and rewinding of the tape.

In the days of linear videotape editing, if you made a change on one section of tape, you had to redo the entire piece from that edit point forward. This was very tedious. I won't even mention the generational loss that occurred when you would copy tapes or add dissolves and other effects. Each move could create a loss of data or detail on the tape.

Choosing an Editing Program
Most computers today are outfitted with software that enables you to make a digital video. Before we get started

on describing a few of the programs, I want to mention again that there are editing programs available that are more advanced than the ones featured in this book. The process and concepts, however, are the same whether you use the entry-level or the professional editing programs.

Arranging Your Clips in a Timeline

Editing with iMovie HD (Mac) or Movie Maker (Windows) is simple and the concepts for both programs are virtually the same. With your captured clips now physically residing in a folder on your hard drive, you should see them in the browser window of the project you created. The next step is to arrange your clips in a timeline.

The timeline is the window strip along the bottom of the editing program. It is where you will build your

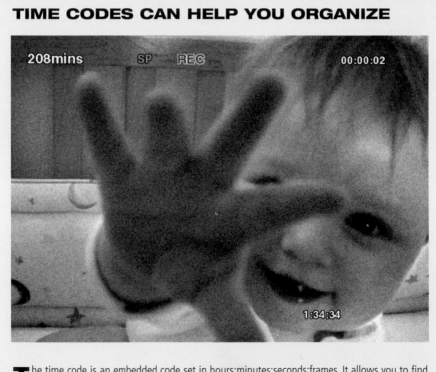

TIME CODES CAN HELP YOU ORGANIZE

The time code is an embedded code set in hours:minutes:seconds:frames. It allows you to find an exact frame either on the digital tape or in a captured clip because each frame is time-coded. This feature can only be found in the more advanced programs.

video from beginning to end, layering it with sound tracks if you like. You build your show by dragging clips into it, one after the other, and placing them in the sequence you want them to appear. Over time you will be able to create an aesthetic approach to your videos by how you sequence your story and layer your tracks. But for now, let's keep the story simple.

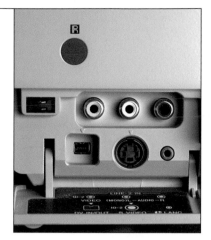

TRANSITIONS

Transitions can add a level of sophistication to your video or, if overused, can ruin it. The key is to begin sparingly, adding key transitions between some of your video clips, but not to overdo it. I call the excessive use of pans, twirls, and such the "used-car advertising" approach. You see it in most attention-getting car advertisements and other types of cheesy videos where the designer uses every graphics tool in the bag. The pictures spin, warp, stream around trees, shake, explode, and more. Yes, they get your attention. However, do not cover up weak video with gimmicks. Those transitions tire all of us and most often get in the way of a good story.

Some camcorders have input and output points that can expedite transfer of digital video to your computer. One of the recent advances is the inclusion of a small FireWire connector (bottom left).

The most common and simple transitions are straight cuts and fades. A straight cut is an edit by which clips are joined together without adding transitions. If you watch a movie that shows actors talking together in a room, for instance, the scene is most likely pieced together using a series of straight cuts between actors and their points of view as they listen or talk. A fade is a slow merging of two scenes or clips by dissolving from one into the other. This technique is most often used for moody imagery or where the editor wants to signal a passage of time.

Here are some other simple transitions I can recommend:

1. Dissolve: This is a transition that fades one clip into the next. You can vary the length of dissolves, but anything over a few seconds begins to draw attention to the transition itself. When you use a dissolve for two seconds, you lose a second of video from each adjoining clip. In other words,

TIP:
Editing Programs to Consider
- Adobe Premiere Elements
- Sonic Foundry Vegas
- Ulead's MediaStudio Pro for the Windows platform
- Apple's Final Cut Express for the Macintosh
- Apple Final Cut Pro HD
- Adobe's Premiere Pro 2.0

0:00:35.00 0:00:36.00 0:00:37.00

Guat part 1 (6)

Guat pa... | Guat part 1 (6)

Opening Part 1

▶ Land of fire land of Prayer

Clip: 100% 5:07:08 tot

there will be a second on each clip that will have the dissolve appearing over it. The key here is to experiment with the length. Sometimes a two- or three-second dissolve can be really nice and dreamy, especially when you add music or sound effects.

2. Wipe: In this transition, which comes in various geometric designs, the incoming clip wipes over the previous clip, covering it up. This can also be reversed, with the outgoing clip revealing the new clip. Be care-

ANIMATION AND 3-D

Special effects and 3-D composing can be accomplished with special programs such as Adobe After Effects and Apple's Shake and Motion. If you find yourself interested in this element of video editing, these are the programs I recommend. I would, however, learn the basics of editing first before attempting these programs. Be warned: The learning curve is steep on these advanced composing programs, and only the truly driven survive. For many beginners, a course taught by a working professional is worth the time and effort.

| 0:00:38.00 | 0:00:39.00 | 0:00:40.00 |

Guat part 1 [6]

Guat part 1 [6]

Opening Part 1

Land of fire land of Prayer

43.6 GB available 43.8 MB

ful; these effects can be really gimmicky. Apple handles the length by letting you preview the timing using a sliding scale. Windows creates a transition overlap in the timeline, and you can lengthen it by increasing or shortening the clip's overlap. Here, again, you'll need to play around with their lengths to get what you want.

3. Push: This is just what it says. The incoming clip literally pushes the previous clip off the screen. A push can come from top or bottom, left or right.

Both Apple and Windows have many transitions for you to try. Windows' Movie Maker includes at least 60.

AUDIO TRACKS

Earlier, I stressed how important gathering good audio is to a successful video. Learning how to add supplemental sounds and music to your sound track will take your video to another level. The beauty of today's video editing programs—even with minimal programs such as iMovie and Movie Maker—is that you can add a track or

two beyond what was recorded on the clip. This is called layering. Movie Maker allows for only one additional sound track other than the audio from your video clip. Apple's iMovie allows for two additional tracks. Adobe's Premiere Elements and Apple's Final Cut programs can add dozens upon dozens of sound tracks with very sophisticated controls over the fades and quality settings.

Understanding the Nature of Sound

As you may remember from your high school physics class, sound is simply the transmission of acoustical waves of energy that the human ear can detect at frequencies ranging from about 20 hertz to 20 kilohertz (kHz). Lower frequencies are recognized as deep tones, higher frequencies as high-pitched.

These audio waves and their frequencies make the eardrum vibrate at rates that determine tone and volume. These analog sound waves are converted into digital "ones" and "zeroes" by electronically sampling them many times a second and recording these values in a sound format a computer can understand. CDs typically have a sampling rate of 44,100 times a second. Most of today's camcorders sample the audio at 48,000 times (or 48 kHz) per second, which is incredibly high quality.

Whether using Windows Movie Maker or iMovieHD, these programs have a library of effects and overlays for text and graphics.

Bit Depth

So what is bit depth and why should you care? Bit depth is the level of quality, or depth, as each sample is taken. Say you take a cup and scoop up ten cups of water per second to place in a coffeemaker. You'd be sampling at ten cups per second at a bit depth of one cup. Now let's say you use the same sampling rate but collect a quarter cup instead of a full one with each scoop. At the end of the sample time you'd have one-quarter the amount of water than previously. The same concept pertains for bit depths of sound. Twelve-, 16-, or 24-bit is considerably better than 8-bit sound. At a lower bit depth, the sound is less defined even though it may be sampled at a high rate.

Now, most important, the sampling rate and bit depth recorded on your camera should be the same as the preference settings on your editing program, and in this case bigger is better. Twelve- or 16-bit at 48 kHz is a good place to start. Fortunately, our editing programs have simplified matters by capturing and converting imported digital audio and video into the proper sample, bit depth, and format.

The point is to stay with a high sampling rate and bit depth for your sound from capture to final edit, and this is because most viewers will notice bad sound over poor-quality video.

Copyright Concerns

Today's technology has made it extremely easy to download audio of existing CDs from your music library.

Apple GarageBand® is one program that can offer more choice for your music and audio tracks. Also, if you play piano, you should look into a MIDI keyboard to connect to your computer.

TIP:

Introduced by Apple in early 2004, Garageband® is a consumer-grade software package now part of the iLife software suite that allows users to create, perform, and edit MIDI (musical instrument digital interface) instruments and prerecorded loops. This program can show iMovie clips to assist in the creation of synced music and sound-effects tracks.

It's just as easy to find music on the Web that's been illegally copied and made available. You should avoid using music for which you don't have rights. Intellectual property rights are aggressively defended by all creative people. How would you like to come home and find people helping themselves to your stuff? Every time you take a song and use it without permission in another creative or public product without asking, you're stealing.

If you start selling the product, you'll find yourself in a heap of trouble and the financial penalties can be considerable. There are many low-cost, royalty-free stock libraries on the Web that you can download from and avoid these legal problems. Also, programs such as Apple's GarageBand have many royalty-free sound effects and music loops that are extremely useful. So pay close attention to how and when you use "borrowed" music, video, and other graphic sources.

Finally, don't ignore the natural world of sound and music. You can capture the wild sounds of nature, or even try your hand at creating music. If you play the piano, why not record a music track? You should also explore the potential of MIDI, the incredible music interface for keyboards and computers. I have been creating music since 1985, and one of the most fulfilling aspects of making a video is using my own sounds and music.

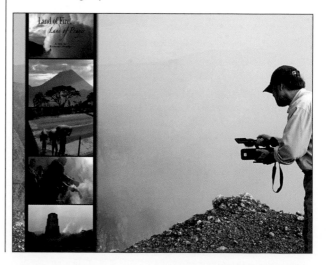

For this film on Guatemala, I spent a lot of time capturing the sounds of the country to run in between the narration.

STILL PHOTOGRAPHS

There is nothing today that prevents you from bringing other visual elements into your video. An obvious choice would be still photos from your family collection. It's easy to scan family photos or slides into your project, adding impact that only stills can provide. You can further enhance your stills by cropping, removing backgrounds, and layering. You can also design and edit logos in graphics programs.

TITLES

Titles for a video have a very important function. They set the mood, help set the location, and interpret dialogue spoken in a foreign language. Many videographers go to great lengths to create beautiful titles and credits.

If kept short and focused, titles can enhance your video and negate the need for excess narration. I'd rather see a slow sweep over the desert with a short title along the bottom that fades in and says "Arizona's Painted Desert" than have someone talking into a microphone. It's much better to let the natural sound and openness of the scene play without someone's voice walking all over the mood of the scene. Remember, the goal of video is to transport viewers into a visual story, so try to keep out of their way as much as possible.

Styles

Basic titles come in two styles: overprint and full-screen. When you overprint a title, words appear over an existing video clip, such as the desert scene I described above. A full-screen title is an entity unto itself. In that case, a created background, either a solid color or a still image, provides the palette for type.

Putting type over the video creates many challenges and requires special care in selecting either dark scenes or very high-key scenes, such as a foggy morning, to allow the clear reading of type over the moving video.

Here are some basic rules for designing your titles:

1. Watch your margins. Televisions, unlike

TIP:

The Importance of MP3 Files

Both Windows Movie Maker and Apple iMovie can import MP3 songs, but the iMovie program can't import WMA (Windows Media Audio) files created in Windows. The best bet if you plan on moving files is to keep them in the MP3 format. There are other higher quality and uncompressed formats such as AIFF, but these take up tremendous amounts of processing power and hard drive space. Until your audio editing skills develop, keep it simple.

The iMovie program has the ability to incorporate photographs from your picture library. You simply navigate through the program's browser to your iPhoto library and drag an image over the video track where you want to insert it into the program.

computer screens, overscan their video. In other words, TVs crop into the picture a bit to avoid showing the outside video frames that carry visual data and information not meant to be viewed.

2. Movie Maker and iMovie both provide the necessary cushion for title-safe margins when you create your text and place it into the video. More advanced programs allow you to turn on (and off) a grid that shows title and safe-action areas on the video frame.

3. Preview your video as you select the color and size of the typeface and the title's run-time. Only by previewing the title sequence can you decide on its proper length. It needs to be just right—neither too long nor too short to read.

4. Keep the text size as large as you can without making it chunky. With HD LCD screens, flickering and shimmering is less of an issue than with older CRT (cathode ray) televisions. In any case, avoid type with very thin

lines or widths. Once again, doing a test DVD and viewing it on a television will show whether you have a problem.

Now experiment with your titles. You can't break anything. Be adventurous and try out various transitions and effects. Some are interesting, but try to stay on the conservative side to start. When you have mastered the basics, then you can define an individual style.

Windows Movie Maker has an easy title window where you can create and insert standard titles with effects into your program.

CONCLUSION

By now you know I can't tell you that there is one way to edit your video. This is something between you and your computer that needs to be worked out, and I can only repeat some guidelines before you dive into the instructions for your program.

1. Try to maintain some semblance of continuity in your story so the viewers can follow the plot.
2. Keep your scenes short and edit unnecessary bits.
3. Use the wide establishing shot to place your audience in a scene, then mix it up with wide, medium, and close-up shots.
4. Create a story with a beginning, a middle, and an end.
5. If you add music, don't hit the audience over the head with it.

TIP:

Stay consistent with typeface, transitions, and effects throughout your video. Viewers will be more comfortable with consistent effects and transitions rather than differing styles.

STEP-BY-STEP INSTRUCTIONS FOR
WINDOWS® MOVIE MAKER®

①

Connect the camcorder to a Windows computer. Turn the camcorder on. A window should open automatically on the computer screen asking you to choose a program. Choose Windows Movie Maker.

③

To troubleshoot a bad connection, go back into the Control Panel in your Microsoft system and find the Scanners and Cameras icon. Click on it.

If the computer doesn't recognize your camcorder (most likely because the camcorder is not turned on or switched to the right setting or compatible with your system), you will get this warning.

Windows Movie Maker

A video capture device was not detected. Verify that a device is turned on and connected properly, and then try again.

OK

④

If you can see your camcorder model in there, it may just be an improper setting. Check your camcorder manual to find the right one. If you don't see your camcorder in there, check the camcorder manufacturer's website.

Scanners and Cameras

File Edit View Favorites Tools Help

Back ▼ ▼ Search Folders ▼

Address Scanners and Cameras Go

Imaging Tasks
- Add an imaging device

Other Places
- Control Panel
- My Documents
- Shared Documents
- My Network Places

Details
Scanners and Cameras
System Folder

Sony DV Camcorder #2

STEP-BY-STEP INSTRUCTIONS FOR WINDOWS MOVIE MAKER

 (5)

Find Tasks on the toolbar and click on it. Click on Capture from Video Device underneath the Capture Video category. A Video Capture Wizard screen will open. Here you're asked to name the project and the folder the captured clips will be saved in.

(7)

Decide if you want to capture your tape manually or automatically. If you choose automatically, the capturing will start once you click Next.

⑥

Next you'll be asked to select a format in which to save the clips. Select the highest setting for your video quality. This option compresses the video in Microsoft .WMV format.

⑧

If you choose manual capture, start your camera using the DV camera controls located underneath the preview window. When you see a clip you want, use the Start Capture and Stop Capture buttons to create it. The clips will automatically appear in the Collection window.

STEP-BY-STEP INSTRUCTIONS FOR
WINDOWS MOVIE MAKER

a.

In the Movie Tasks sidebar, you can open the Import Video window if you need to bring in more clips from a previous file for your video.

9 b.

Find the file name where your video clips reside in your library by scrolling through the window at the bottom of the screen seen here.

⑩ a.

You have two options for editing styles: Storyboard or Timeline. To see them, click on the film clip icon underneath the Movie Tasks sidebar.
(Shown: Storyboard)

⑩ b.

The Storyboard method includes all tracks and transitions. The Timeline allows you to sequence the pictures more easily.
(Shown:Timeline)

STEP-BY-STEP INSTRUCTIONS FOR
WINDOWS MOVIE MAKER

Start dragging your clips into the Timeline by the click and drag method.

Guat part 1 (26) Guat part 1 (27) Gu

To preview your work after you have placed a few clips in the Timeline, hit the Play button in the Timeline tool-bar, located next to the film clip icon.

(12)

To preview your clips before you drag them in, select the clip and click on the Play button underneath the Preview window.

(14)

If a video clip has unusable material at either the front or end of it, you can edit these out in the Timeline window. Toggle to the Timeline and select the clip. You will see a purple line that indicates the beginning of the clip.

STEP-BY-STEP INSTRUCTIONS FOR
WINDOWS MOVIE MAKER

Drag the purple line across the clip to indicate the new starting point you want. In the preview window you can see the pictures you are removing. The same can be done with the end point of the clip.

⑰

You can also split your clip before you drag it into the Timeline. Drag the Playhead button underneath the Preview window to the place you want to split in your clip. Click on the Split Clip button in the lower right-hand corner of the Preview window.

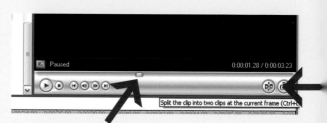

If you want to split a clip, double click the clip to preview it in the viewer. Move the timeline cursor to where you want to make the split. From the menu, select Clip>Split. Use Ctrl + Z to undo anything you don't like before saving.

To insert a transition into the Storyboard version of the Timeline, go to the Collection drop-down window and select Video Transitions. Choose one of the 66 options.

STEP-BY-STEP INSTRUCTIONS FOR WINDOWS MOVIE MAKER

⑲

Drag your chosen transition into the Transition Box located between each clip in the Timeline. To change the duration of the transition, drag the ends in the Timeline as you did with your clips.

㉑

Next, move the cursor in the Timeline where you want to begin recording narration and then click Start Narration. Click Stop Narration when you're done.

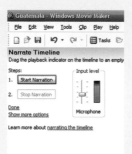

To add narration, connect your microphone (it usually needs a mini-plug connector) to your computer. Select Tools > Narrate Timeline. Select Show More Options in the narration window and make sure you see the audio card in the first drop-down and that in the second drop-down window you see that Microphone is selected. The colored Input level bar helps you adjust the sound.

To add music from a CD, go back to the Movie Tasks sidebar. Select Import audio or music from Capture Video task menu. Select a song from the library shown in the pop-up window. Make sure you bring the song into the correct Collection window (the video you are editing.)

STEP-BY-STEP INSTRUCTIONS FOR WINDOWS MOVIE MAKER

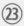

Drag the music clip into the Audio/Music track in the Timeline where you want it to be. You will see a blue line of audio frequencies and the name of your song. If you want to shorten the music clip, drag the ends as you did the video clips.

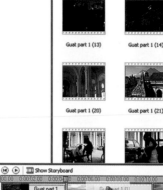

Enter the text for the title and the subtitles in the appropriate boxes. You can select More Options in this window to personalize your title. Preview the title by playing it in the Preview window. Click Done.

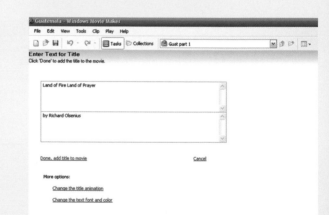

To create a title, move the
Playhead in the Timeline to
the place where you want
the title to appear. Go to the
toolbar and select Tools >
Titles and Credits. Select
from five choices given.

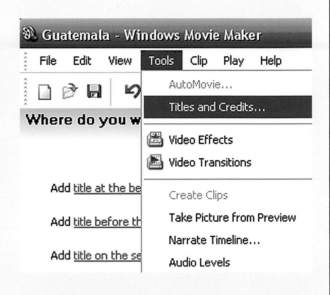

You can adjust the timing
and the length of your title in
the Timeline after it appears
in the Title Overlay track by
dragging the edit points on
it. To remove a title, simply
select and delete.

STEP-BY-STEP INSTRUCTIONS FOR APPLE® IMOVIE®

① Insert a tape into your camera and connect the camera by FireWire cable to your Macintosh computer. Turn the camera on and switch it to the VTR or VCR position.

③ In the lower toolbar on the left side, you will see a toggle switch. On the left is a camera icon for importing and on the right is a scissor for editing. Toggle to the camera.

②

Open iMovie. In the top toolbar, select File > New. A Create Project window will appear. You will need to verify the format of your camera and name a folder where the captured clips will be imported.

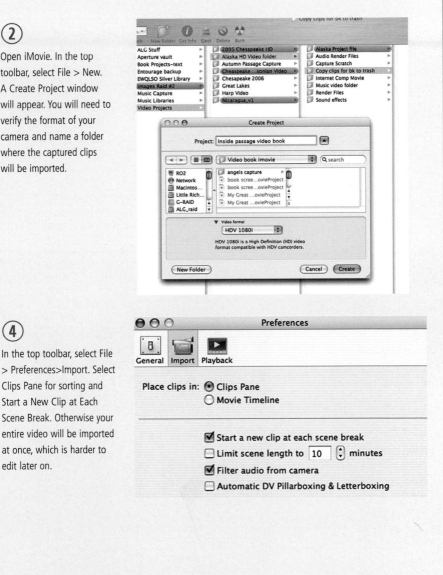

④

In the top toolbar, select File > Preferences>Import. Select Clips Pane for sorting and Start a New Clip at Each Scene Break. Otherwise your entire video will be imported at once, which is harder to edit later on.

STEP-BY-STEP INSTRUCTIONS FOR APPLE IMOVIE

⑤

The other way to import is to run the camera manually. A small Import button sits at the bottom of your video as you watch it on the computer. Click on this when you want to begin and end clips. The clip will appear in the windowpanes next to the main video window.

⑦

To preview and trim clips *before* you drag them into the Timeline, select a clip in the Clips Pane window to the right. The clip will be outlined in blue. At the bottom of the main video window, slide the in and out triangles to where you want to trim the clip. In the menu, Select> Edit>Crop. To undo, Select>Advanced>Revert to Original.

⑥

Once you have captured all your clips, move the toggle switch to the scissor icon. To the left of the toggle switch are two Timeline options. The left is for the Storyboard view and the right is for the Timeline view.

⑧

Drag your clips down to the Storyboard version of the Timeline in the order you like.

STEP-BY-STEP INSTRUCTIONS FOR APPLE IMOVIE

⑨

To preview your work so far, place your cursor on the Playhead, located in the blue bar at the bottom of your video screen, and move it to where you want the video to begin. A corresponding red line in the Storyboard verifies where you are in the video as well. Hit the Play button.

⑪

Drag the selected transition down to the Storyboard and place it over the Transition Box, usually signified by a blue square. A red bar under the new transition lets you know the transition is processing.

⑩

To add transitions, highlight the Editing button in the lower left toolbar. Select Transitions in the upper right toolbar. A menu of transition options will appear. Select one.

⑫

To trim either individual clips or transitions, go to the Timeline by highlighting the Timeline button at the far left. Select the clip by clicking on it. (The clip highlights in a blue color.) Use the In diamond and the Out Diamond located underneath the video to create new entry and exit points. A yellow highlight defines the new clip length.

STEP-BY-STEP INSTRUCTIONS FOR APPLE IMOVIE

⑬

You can also trim a clip by adjusting the in and out points. Go to the top toolbar and click Edit > Crop. You can revert back to the original clip by clicking Ctrl + Z or go to the top toolbar and click Advanced > Revert to Original.

⑮

Back in the iMovie program, click the Media button located on the lower right-hand toolbar and click Audio in the top right-hand toolbar. With both buttons selected, you can narrate your story by placing the Playhead in the Timeline where you want to begin and then clicking the red Record button on the screen with your cursor. Begin speaking into the microphone.

⑭

To lay in narration, check to make sure your USB microphone is properly selected in your OS X® System Preferences. Go to Preferences > Sound > Input Device. You can also check sound levels here.

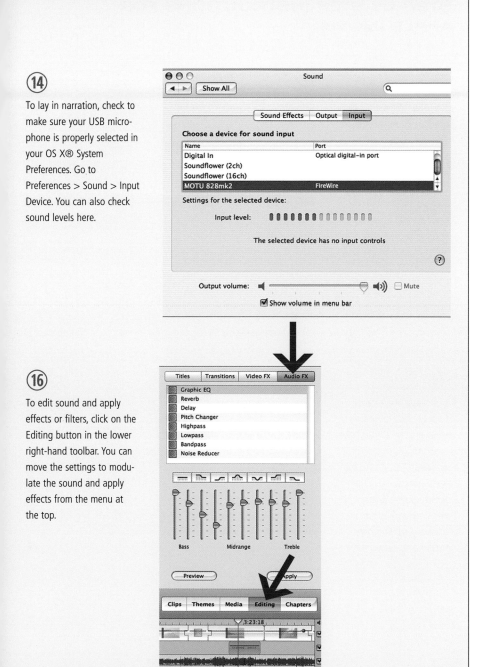

⑯

To edit sound and apply effects or filters, click on the Editing button in the lower right-hand toolbar. You can move the settings to modulate the sound and apply effects from the menu at the top.

STEP-BY-STEP INSTRUCTIONS FOR APPLE IMOVIE

⑰

To adjust volume levels to get a good mix of narration and background music, place your cursor on the lines within either the audio or video tracks within the Timeline. You can raise or lower the individual track levels by dragging that line up or down.

⑲

To create a Title, click the Editing button in the lower right-hand toolbar. The Titles button should be highlighted in the upper right-hand tool-bar. Select the clip in the Timeline where you want the title to appear. Type in your title and subtitle into the appropriate boxes in the win-dow. Choose your colors and effects. Click Add.

(18)

To import music from a CD, select Media in the lower right-hand toolbar. In the top menu you can select sound clips from GarageBand or songs from your iTunes library. Make sure you are still in Timeline View. Drag the desired sound clip into the Timeline at your desired location.

(20)

To preview the title, place the Playhead at the begin-ning of the clip and press the Play button. You can adjust the speed and duration of the title by moving the tiny blue buttons on the sliders at the right.

ORGANIZING YOUR VIDEO CLIPS

In the professional world of video production, the relationship between a producer and an editor can be an effective partnership in storytelling. The producer identifies the narrative force that drives the story from beginning to end. And the editor brings the story to digital life by matching, clipping, and layering hundreds of bits of video and sound into a finished video.

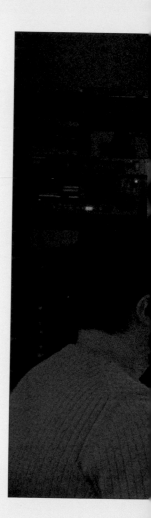

This meshing of a rough outline, stock footage, and creativity usually happens in a darkened room with lots of screens—4 LCD flat screens and one television set to be exact in this case. John Bredar, producer, and Lisa Frederickson, editor, are making a 15-minute introductory film about the National Geographic Society.

On the left screen, Lisa has created "bins" for all of her video clips, which she has spent hours clipping and storing from library footage and recent footage. At the bottom of the second screen is a "timeline"— a violet-colored timeline in the shape of a ruler in which she has stacks of video clips and audio clips she moves at random as she works through the outline with Bredar. "It's okay to be fearless in your attempt to tell a story," she says as she rapidly clips audio from an interview and lays another picture over it.

Fredrickson learned her craft in two ways: she watched a lot of movies and she learned the applications of editing in the film world. Now she freelances in the "nonlinear" world, including clients such as National Geographic and the Discovery Channel. She starts with a detailed outline of the story. As she researches footage, audio interviews, and still pictures, she creates a library of "bins" in which she places identifiable clips. (Sourcing her clips in her naming convention is key.) "It's all a process of refining," says Frederickson, who probably spends 50 percent of her time on a project simply organizing the folders so she can access them quickly while she is actually editing with the producer in the room. She adds, "You're not worrying about being creative while you are organizing but you are being creative."

"Don't be afraid to edit what isn't good," Frederickson

Jim Sheehy, an HD online editor for National Geographic, works on a video in one of the editing suites.

adds as she listens to a clip from an interview where static disrupts the quote. "If the information is not good enough then you can lose your viewer."

She examines a clip of fish swimming languorously in front of a diver with a film camera as the filmmaker explains his approach to his work. She winds and rewinds the 10-second clip. "Sometimes it's not just the content of your clip," she says as she raises the sound level and searches for her entry point to start clipping. "Sometimes it's better to figure out the right moment to get out of a scene."

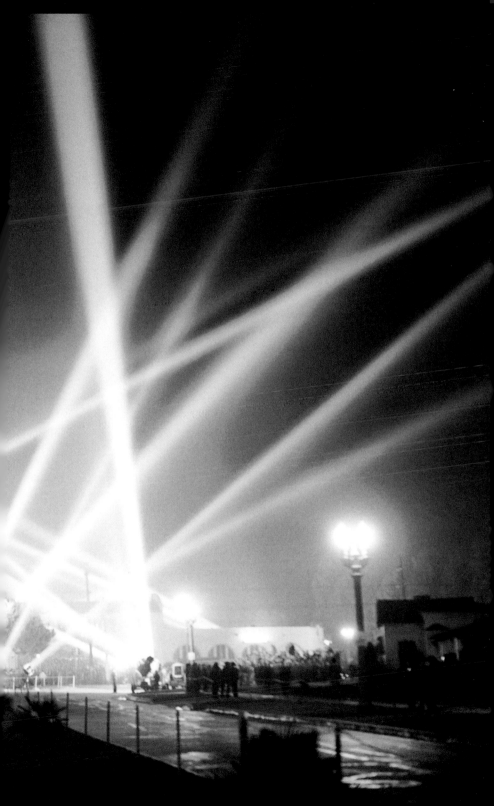

At this point, many of you have shot and edited your video and are ready to share it. It might be a good idea now to have a trusted friend or spouse come up to your "editing suite" and watch it on the computer. This is the best place to get a final review because you have a good monitor, good speakers, and the ability to start and stop the movie just by pressing the space bar.

Once you "put a wrap" on your video, you need to decide what the final size of your movie should be. Whether you want to make a DVD or stream it on the Internet will determine the size as you take your video through the process called "rendering" or "compression."

What's a Video Codec?

I know that for most readers technical jargon is soporific, but the following paragraphs contain the essential information you need in order to transfer your work successfully to a DVD or a page on the Internet.

"Codec" is short for "compression and decompression." Specifically, it is either a video hardware device or a software compression scheme that reduces the data size of digital video and music. With great success, engineers developed video codecs that minimize the loss of information during the compression and decompression of the video stream.

Microsoft, Apple, Sony, JVC, Panasonic, and other companies have all backed the use of codecs in their own products. From this effort Apple developed QuickTime and Microsoft developed AVI (Audio Video Interleave) and WMV (Windows Media Video).

There is also the MPEG (Motion Picture Experts Group) codec, the family of standards used for compressing video and music. The MPEG-3 standard is the format for most MP3 music players, while MPEG-2 is the method for compressing most movies to DVDs. MPEG-4 is becoming the standard for delivering professional-level audio and video across a broad spectrum

of bandwidths such as cell phone, broadband, and High-Definition.

There's a new part of the MPEG-4 standard—called H.264 by Apple—that delivers incredible video quality for DVD and HD. H.264 is an example of the continued

Video is readily available on the Internet as a feed or for download thanks to the increased use of broadband in the home.

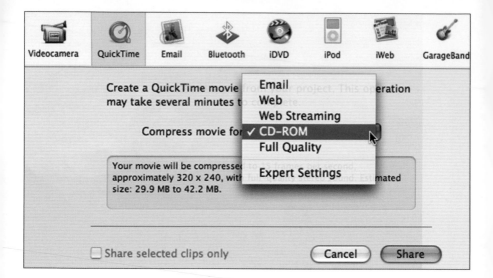

Videocamera QuickTime Email Bluetooth iDVD iPod iWeb GarageBand

Create a QuickTime movie ~~from your project. This operation~~ may take several minutes t~~o complete.~~

Compress movie fo

| Email |
| Web |
| Web Streaming |
| ✓ CD-ROM |
| Full Quality |
| Expert Settings |

Your movie will be compresse~~d to...~~ approximately 320 x 240, wit~~h...~~ mated size: 29.9 MB to 42.2 MB.

☐ Share selected clips only (Cancel) (Share)

This window in iMovie displays all the ways you can share your video with other people.

development of video compression with comparable increases in quality. H.264 can deliver video up to four times the frame size at one-third to one-half the data rate of MPEG-2.

Exporting Video with iMovie

Apple's iMovie video program has a "sharing" window that lays out your options in eight categories:

1. Videocamera
2. QuickTime
3. E-mail
4. Bluetooth
5. iDVD
6. iPod
7. iWeb
8. GarageBand

Let's look at the first one: Videocamera. Clicking on this icon gives you three options. One option is to connect directly to your camcorder and save the video back to the camcorder. The second is to save it to a file to be transferred back to the camcorder at a later time. The third is to transfer other movies that you might have previously edited and finished. So let's take the first option and dub your movie back to your video camera.

1. Put a blank tape into the camcorder, turn it on, and switch it to the VCR or VTR mode. Next, go to

iMovie's menu and select Share from > Videocamera > Share this video to your camera now. At this point you might have to wait for the video to render all the transitions and audio tracks before it starts sending to the camcorder. If the camcorder is on and in the correct mode, it should start recording automatically when iMovie is ready to share. As long as the video format in iMovie is the same as the camcorder's (e.g., sending a DV 720 x 480 movie to a camera recording in DV), it should go flawlessly.

2. Once the program is dubbed, unplug the camcorder and take it to a TV or flat-panel screen and connect the camcorder's output cable into one of the inputs (video, left; and audio, right). Now sit back and watch your show.

Congratulations! You have successfully downloaded video from your computer with all your edited, trimmed clips, along with layered sound, back to your camcorder and you are watching it on your TV. How great is this?

TIP:
MPEG Definitions

1. MPEG-1 is the oldest version of MPEG, with a maximum picture size of 352 x 240.

2. MPEG-2 offers full-size video at much higher quality. When you burn your video to a DVD, this is the compression format you will use.

3. MPEG-3, the ubiquitous format for MP3 players, is the format used for most music files shared over the Internet today.

4. MPEG-4, the newest standard for video, is a hybrid of Apple's QuickTime and MPEG standards. It offers very high quality with small file sizes.

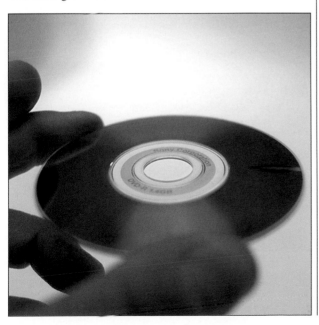

The storage capabilities continue to change rapidly. Blu-ray and HD-DVD are readily available now.

Within the Videocamera sharing window you have the ability to save this movie as a file. It's not a bad idea to render all your movies to a file and burn them to a DVD as a backup. Remember-saving and burning a video file to a DVD or CD is different from rendering your movie into a DVD-playable movie. When you create a DVD movie, your video gets compressed as a DVD MPEG video stream and cannot be opened in your editing programs without going through a series of "demuxing" steps.

BURNING YOUR VIDEO TO A DVD

The next important step for you and your video is to render it into a format that can be viewed outside your living room or computer. Sharing your video as a DVD-playable movie is the simplest way to maintain quality and ease of use. Most everyone has a DVD player, and almost all the newer computers have DVD burners/players with included DVD-authoring software.

Always play your DVD before you ship it off to your parents, boss, or client. There's always the chance you did something wrong and it won't play.

CREATING A DVD IN MOVIE MAKER

The "Save Movie Wizard" on Windows is straightforward. In "Movie Tasks," click the tab "Save to DVD." This

brings you to a couple of simple steps to DVD creation. Design creativity with Movie Maker is limited compared to other available softwares, but it does the job if all you want is a simple movie for Uncle George in Seattle to play on his TV.

1. The movie is rendered and saved before it is written to the DVD.
2. If you have a recognized DVD burner, the DVD creation window becomes active for your input and you can name the DVD and the movie you've created. These titles will appear on the DVD and are what people will see on the Menu screen when they play it back.
3. Make sure the correct DVD burner is selected and type in the number of copies you want to make. To begin, I would burn just one. You don't want to burn 10 and then find you've misspelled your name or worse.
4. Click the Create DVD option and wait for the process to complete itself.
5. Eject the DVD and then insert it back into the computer to see whether Windows Media Player or some other DVD player opens your new DVD. If you use outdated software, or your computer is old, or you have insufficient DVD-recording speeds, be prepared to have some problems. This burning process has been simplified on the software level, but trust me, there's some very complex stuff going on here. Don't be discouraged if it takes extra effort to burn your first DVD.

BURNING AN APPLE IDVD

Apple's iLife software collection is easy to use. You can also render and burn your iMovie into a sophisticated-looking DVD with DVD chapter markers in the editing process. Why is this helpful? Well, suppose you take a coast-to-coast trip. This feature will let you move around easily in your DVD between, say, various cities or weeks in the trip.

1. Select Chapters Tab > Add marker (at current playhead). This will add a chapter reference to a list that also allows you to give it a title or scene name. This is a handy tool if you have a number of locations on a

TIP:
Be sure you have the correct blank DVDs. The two standards are DVD+R and DVD-R. If you have an older burner, know which standard it recognizes before you go to the store. New burners, I'm happy to report, will handle both.

vacation or important movie scenes you want to access quickly. When you save iMovie, all your chapter notes or markers are saved with the project.

2. When your video is done and you've corrected mistakes and added chapters to significant parts, go to the Menu bar and select Share > iDVD. This opens the iDVD program. Now you can design the look of your video and the navigation buttons.

3. Apple has many opening menus, the kind you see at the beginning of a Hollywood movie you can buy or rent on DVD. Review all the "Themes" for the main menu

The quality of your work can be just as good as the films you see in movie theaters if you pay attention to the basic principles and use the right equipment.

and select one that you like.

4. After you settle on the overall look and feel of your DVD in the "Themes" window, open the Menu tab window to where you insert stills and your movie into drop zones. You can also select Auto Fill and clips from the movie will be automatically inserted. Try this with the "Reflection" theme and see how stunning the effect can be.

5. If you want to make your own selections for the drop zone picture or movie elements, click on the drop zone you want to fill, then select Media from the tabs,

and you will see your iPhoto and iTunes libraries. Simply select a photo or video from your library and then click Apply.

6. The Button tab allows you to refine the shape, type, and color of the buttons along with the transition actions they use when they are clicked.
7. During all this fine-tuning of your DVD, you can easily preview the work as you go along, or look at the physical structure and link relationships of your video, by clicking on the main interface buttons in the main window.
8. Now just "Burn your DVD" to either your internal Super Drive or an external drive that burns DVDs.
9. Be sure to save your movie and DVD projects if you want to go back and make changes or burn new DVDs.

SHARE YOUR VIDEO IN E-MAIL

Sending your new digital video as an attachment in e-mail is possible but remember the golden rule: "Do unto others as you'd have them do unto you." If you send a gigantic digital video file to someone who doesn't have a high-speed Internet connection, you could be tying up their computers, and their patience, for endless hours.

Both Microsoft Movie Maker and Apple iMovie include easy steps to downsize movies for sending as e-mail attachments. Windows sends a "WMV" movie that unfortunately excludes Macintosh users from seeing it unless they have installed a WMV plug-in for their QuickTime player. Apple's iMovie creates a QuickTime movie as an attachment but most Windows users have QT installed. If not, there's a free download for QuickTime on Apple's website. Go to: www.apple.com/quicktime/download/win.html.

SHARE YOUR VIDEO ON THE WEB

Not too long ago, the idea of making videos and showing them on the Web meant having a super-fast Internet connection and a streaming video server that cost thousands of dollars. With today's speedy Internet connections—along with a number of services that will stream your video—enthusiasts are now able to serve up their own videos for very little cost. Couple

that with the Apple H.264 and Windows WMV codecs, and you can understand how the quality of this streaming video has captured everyone's attention.

If you have a broadband Internet connection, just sample the streaming movie trailers on iTunes.com to see what I mean. These clips are streaming at incredible resolutions and quality. Most of us don't have the time or inclination to set up our own video-streaming website to share videos, but there are some interesting alternatives that have exploded on the scene. If you haven't already, take a look at YouTube.com and MySpace.com or a new video-display site called BrightCove.com.

Both Movie Maker and iMovie have a "sharing" choice for formatting your video into a Web-friendly size and data stream. Developing a website where you can stream or download your video is much easier in iMovie because it transfers you to iWeb, where you can immediately create a Web page with the embedded movie. If you have a .mac account, you can publish pages where people can view your videos, still photos, and more.

Video-sharing websites are the newest way to distribute your video.

Sizing Your Video for the Web

For all the dreaming I've done about distributing video, I never thought I'd see the day when I could video the Blue Angels during an air show and publish it around the world the same day. Enter video-sharing websites. Not only are the sites a place for you to upload your finished videos, it is a blooming cultural phenomenon. People log on just to get their news and see what the rest of the world is producing. Once you register, any video you shoot can be published on YouTube.com or MySpace.com, two examples of video-sharing websites. Here is how easy it can be to do:

1. Any device that captures digital video will work, as long as you have a way to download it from your capture device to your computer. This includes cell phones, digital still cameras, and most camcorders. The file formats should be in .AVI, .MOV, or .MPG.

2. As you edit your video in Movie Maker or iMovie, add sound and music. Keep your video under three minutes if you can. When you're satisfied with your edit, save your video in MPEG-4 format with a frame width no wider than 320 pixels. If you resize your video downward from your video in Movie Maker or iMovie, you'll achieve the best quality when you upload it to YouTube.com. Be sure you save this new size under a different file name so you don't write over any full-size masters. If you upload the video to YouTube.com and it's not the correct size, YouTube.com will resize and encode it to their specifications, but the quality won't be as good as when you resize it yourself. Audio should be in the MP3 format. Just remember, "garbage in, garbage out."

3. Register an account on YouTube.com (same for MySpace.com) and you can upload your video. (Uploading is sending data from your computer to the Internet, while downloading is importing data off the Internet and into your computer.) When you upload to YouTube.com you can categorize your videos and set keywords. Be logical with your choice of words to help people find your video. Do not tag the video with something unrelated or sensational just to get hits. In the long run, your video will get flagged and you could be considered a problematic member.

4. The limit on size as of this writing is 100MB and 10 minutes in length. With a high-speed Internet connection it could take 1 to 5 minutes to upload for every 1MB of movie file size.

The downside of YouTube.com, and other websites like it, is the shear volume of material. Some of the most basic and poorly shot material is dumped onto it. There's a lot of garbage out there but there's also good and interesting material.

TIP:
Be careful not to use copyrighted material when adding sound tracks to a video you plan to upload onto a video-sharing website.

MOVING VIDEO TO A PORTABLE VIDEO PLAYER

The fact that you can walk around with a video player the size of a credit card still amazes me. Media companies have begun to downsize their movies and television programs so that you can download them into your iPod or Zune to play whenever you want. The same goes for all the various podcasts that have hit the Web. Podcasts, for those of you who've been away for a while, are video and audio content that can be downloaded from the Internet using Apple's iTunes service.

So what does this mean for you as a videographer? It is another outlet for your videos.

SIZING YOUR VIDEO FOR THE IPOD

If you're on the road, you can easily connect an iPod video cable to almost any modern television to show friends or clients your digital video. The picture won't be High-Definition quality, but if you want to travel light, this method is great for showing your video.

1. Select Share > iPod. From iMovie, the program compresses your video into the Apple H.264 format at a frame size of 320 x 240 pixels.
2. Once compressed, the movie is saved in the iTunes library where you can sync it with your video iPod. Now you can show off your vacation to the person you're sitting next to on the plane. Or just watch it yourself!

iPods and other MP3 devices like it may be the next frontier for video you can download and take with you.

Index

Photo Credits

All photographs are by Richard Olsenius unless otherwise noted below:

4, Jeff McIntosh/iStockphoto.com; 8-9, Randy Olsen; 12, Jason Roos; 13, Peter Marlow/Magnum Photos; 14, Newmann/zefa/CORBIS; 17, Bruno Vicent/Getty Images; 18-19, Peter Carsten; 21, Yang Liu/CORBIS; 25, Pixland/CORBIS; 28 (LO), Justin Sullivan/Getty Images; 33, Michael Nichols; 44, Michael McLaughlin/Gallery Stock; 46-47, Cheryl R. Zook; 48-49, Malte Christians/Getty Images; 51, Martin Puddy/Jupiter Images; 78, Martin Barraud/Getty Images; 91, Douglas Miller/Getty Images; 92-93, Dave Ruddick; 94-95, Bob Gomel/Getty Images; 101, Yuriko Nakao/Reuters/CORBIS; 106, Lesley Robson-Foster/Getty Images; 142-143, Bettmann/COR-BIS; 150-151, Fayez Nureldine/Getty Images.

THE ULTIMATE FIELD GUIDE TO DIGITAL VIDEO

RICHARD OLSENIUS

Published by the National Geographic Society
John M. Fahey, Jr., President and Chief Executive Officer
Gilbert M. Grosvenor, Chairman of the Board
Nina D. Hoffman, Executive Vice President;
 President, Book Publishing Group

Prepared by the Book Division
Kevin Mulroy, Senior Vice President and Publisher
Leah Bendavid-Val, Director of Photography Publishing
 and Illustrations
Marianne R. Koszorus, Director of Design

Barbara Brownell Grogan, Executive Editor
Elizabeth Newhouse, Director of Travel Publishing
Carl Mehler, Director of Maps

Staff for this Book
Bronwen Latimer, Editor and Illustrations Editor
Peggy Archambault, Art Director
Sarajane Herman, Copy Editor
John Bredar, Editorial Consultant
Marshall Kiker, Illustrations Specialist
Connie D. Binder, Indexer
Mike Horenstein, Production Project Manager

Jennifer A. Thornton, Managing Editor
Gary Colbert, Production Directort

Manufacturing and Quality Management
Christopher A. Liedel, Chief Financial Officer
Phillip L. Schlosser, Vice President
John T. Dunn, Technical Director
Chris Brown, Director
Maryclare Tracy, Manager
Nicole Elliott, Manager

Founded in 1888, the National Geographic Society is one of the largest nonprofit scientific and educational organizations in the world. It reaches more than 285 million people worldwide each month through its official journal, NATIONAL GEOGRAPHIC, and its four other magazines; the National Geographic Channel; television documentaries; radio programs; films; books; videos and DVDs; maps; and interactive media. National Geographic has funded more than 8,000 scientific research projects and supports an education program combating geographic illiteracy.

For more information, please call
1-800-NGS LINE (647-5463)
or write to the following address:

National Geographic Society
1145 17th Street N.W.
Washington, D.C. 20036-4688 U.S.A.

Visit us online at
www.nationalgeographic.com/books

For information about special discounts
for bulk purchases, please contact
National Geographic Books Special Sales:
ngspecsales@ngs.org

Library of Congress Cataloging-in-Publication Data
Olsenius, Richard, 1946-
 National Geographic the ultimate field guide to digital video / Richard Olsenius.
 p. cm. -- (The ultimate field guide series ; 3rd)
 ISBN 978-1-4262-0122-6 (alk. paper)
1. Digital video--Amateurs' manuals. 2. Digital cinematography--Amateurs' manuals. 3. Video recording--Amateurs' manuals. I. National Geographic Society (U.S.) II. Title. III. Title: Ultimate field guide to digital video.
 TR896.O67 2007
 778.59--dc22
 2007061226

ISBN 978-1-4262-0122-6

Printed in Spain